A–Z
OF
STAMFORD
Places - People - History

Christopher Davies

AMBERLEY

First published 2019

Amberley Publishing
The Hill, Stroud, Gloucestershire, GL5 4EP
www.amberley-books.com

ISBN 978 1 4456 8529 8 (print)
ISBN 978 1 4456 8530 4 (ebook)

British Library Cataloguing in Publication Data.
A catalogue record for this book is available
from the British Library.

Typesetting by Aura Technology and Software
Services, India. Printed in Great Britain.

Contents

Introduction

The origins of Stamford are unclear, but there is enough historical and archaeological evidence to indicate its status in the late Saxon period; that is to say, in the 200 years before the Norman Conquest. It was an important Anglo-Danish borough, a military stronghold and was ideally placed for a market. It was also an important industrial centre. The fact that a Saxon mint was established here bears witness to the economic importance of the town. Archaeological evidence points to an extensive iron-smelting industry on the eastern outskirts of the town. There is also evidence for a thriving pottery industry as well.

During the Norman period its importance continued and it was one of the few non-county towns in which the Normans established a castle. The Middle Ages saw the town at the height of its prosperity, a thriving commercial centre with wool as its chief commodity. This is, perhaps, reflected in the fact that Stamford had fourteen parish churches. In addition, all of the main monastic orders established houses in the town. In the twelfth century there was a short-lived, but nevertheless serious, attempt to establish a university in the town.

The sixteenth and seventeenth centuries were something of an anti-climax, with the town entering a period of decline. The Reformation saw the closure of the monastic establishments. Several of the parishes were amalgamated in the 1540s, leaving just the six parishes we know today. In 1541, Stamford was listed by Parliament as one the the 'decay'd' towns of the realm. Major changes in the wool and cloth industry, which saw other towns prosper, were a significant blow to Stamford as there were no other industries to replace the wool trade. The plague outbreak of 1604 was another severe blow to the town, resulting in some 600 deaths. However, in the late seventeenth and early eighteenth centuries, with the river once again navigable and improvements made to roads, there was something of a renaissance with the town capitalising on the increase in coaching and the development of the brewing industry.

Over the centuries, Stamford has had many epithets applied to it. In the eighteenth century, William Stukeley described it as 'the most elegant town upon the great north road'. Even before that, in 1697, Celia Finnes had observed it was 'as fine a built town all of stone as may be seen'. Such accolades have continued to the present day with, more recently, Stamford being voted one of the best places in England to live. The town's population is, however, growing bigger, which puts more pressure on its narrow streets from both people and the ubiquitous motor car. It is fortunate that in 1967 the town was designated the country's first Conservation Area. This has clearly done much to preserve the town's historic core, but not before some irreparable damage was done to the townscape with some ill-conceived post-war building.

In compiling this short book, I have not chosen to take a geographical approach to the town of Stamford, such as one would find in a normal A–Z. Instead, I have taken a number of different aspects of the town's history, and arranged them in an alphabetical format. So here, the reader will find snippets about people and aspects of the town's history as well as information about some of the streets.

With a book of this size and word limit, it is not always possible to tell the whole story, so I have tried to provide readers with some basic information about the town which, hopefully, will encourage them to look further. Those readers wishing to know more will find much to interest them in Martin Smith's *Stamford Now and Then*, and *The Story of Stamford*. Alan Rogers' *The Book of Stamford* provides a similar overview of the town's history. Those interested in the twelfth-century university should certainly read N. J. Sheehan's *Stamford University: The Stuttering Dream*. These and other local history books on the town will provide an excellent overview of the town's long and distinguished history. If all else fails, look in the local collection of the public library, which is an excellent resource for local history material.

A1

It seems inconceivable that the A1 once wound its way through the heart of Stamford. Yet, until the opening of the north-south bypass in 1960, Stamford was, in the words of the British Pathe News, one of the most congested towns on the Great North Road.

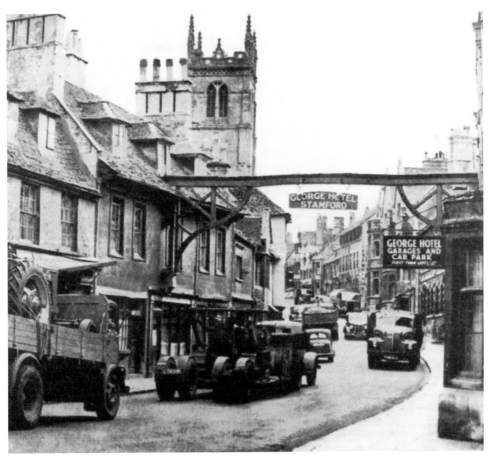

A typical busy scene in High Street, St Martin's, before the opening of the bypass.

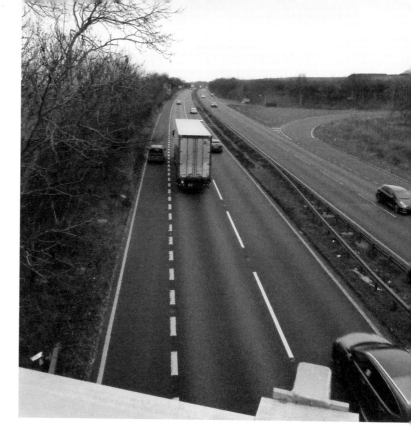

The A1 bypass today.

Certainly it was a significant bottleneck on the north-south route, which was not helped by the town only having one bridge across the Welland. At that time the High Street was also open to two-way traffic, so this necessitated a police officer on point duty in Red Lion Square to control both the through traffic in and out of High Street. However, all of this ended in November 1960 when, three months ahead of schedule, the new bypass was opened by the then Minister of Transport Ernest Marples. Being 4 miles long, and costing one and a half million pounds, the bypass brought welcome relief to the streets of Stamford. Over the next forty years, the increase in volume and speed of traffic resulted in numerous problems at the Carpenters Lodge roundabout. There had been plans to upgrade the bypass to motorway standards, but these were dropped in 1996. The issues at Carpenters Lodge roundabout were finally addressed in 2005, when the Highways Agency announced the preferred route for the proposed improvements to the A1. The new road layout was finally opened in 2008. Increased traffic, however, means that an east-west bypass is still sorely needed in order to ease congestion in the town.

Albert Bridge

The Albert Bridge, in Water Street, was opened in 1881 and replaced an earlier iron bridge built by A. Salvin. That the Albert Bridge was built so quickly is probably due to its proximity to the Great Northern railway station.

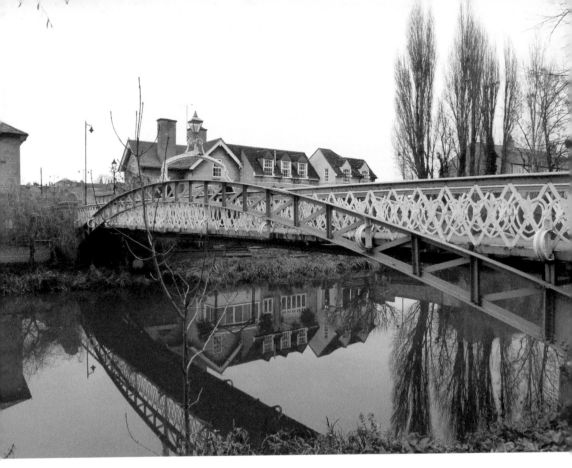

Above: The Albert Bridge, built in 1881 to replace an earlier bridge that was swept away in the flood of 1880.

Left: The Albert Bridge, looking from the north.

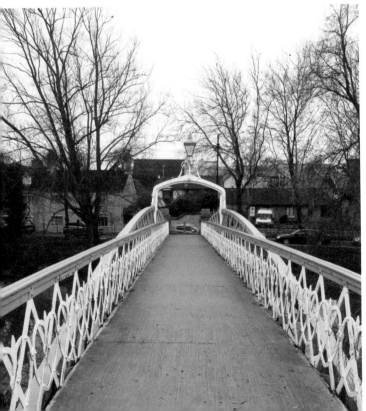

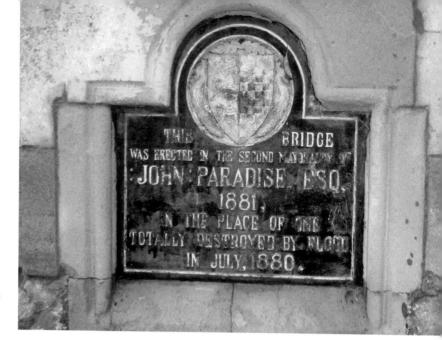

Commemorative plaque on the Albert Bridge.

Almshouses

Rather confusingly for the newcomer to Stamford, almshouses are often referred to as hospitals and, occasionally, as a 'callis'. Leaving aside Browne's Hospital (see under B), the most imposing of the remaining almshouses is probably Lord Burghley's Hospital on Station Road. This was founded by William Cecil in 1597. The present hospital occupies the site of the earlier hospital of St John and St Thomas which had been founded sometime between 1170 and 1180 for the relief of travellers and the local poor. This earlier hospital was purchased by Cecil in 1549 and maintained as an almshouse, but was not formally endowed until 1597. The hospital was established for thirteen poor men, one of whom would act as the Warden. Also in St Martin's parish is Fryer's Hospital on Kettering Road. This hospital was founded in 1832 under the will of Henry Fryer, a local surgeon who also left money for the establishment of the Infirmary. The hospital was designed by George Basevi. This almshouse was to accommodate six poor widows.

Hopkin's Hospital, St Peter's Street, dates from 1773 and although it bears the name of John Hopkins, then mayor, the fact that the Borough arms are on the building suggests that the Corporation had an interest in the hospital. In this case, the accommodation was intended for poor married couples.

Fryer's Hospital, Snowden's Hospital and Hopkin's Hospital are now administered by the Stamford Municipal Almshouse Committee.

Snowden's Hospital, Scotgate, was founded by Richard Snowden in 1604, to house seven poor widows. By the nineteenth century the original building was becoming dilapidated and, in 1823, a new almshouse designed by Thomas Pierce was built. Snowden's ceased to be an almshouse some years ago, and the building is now used for

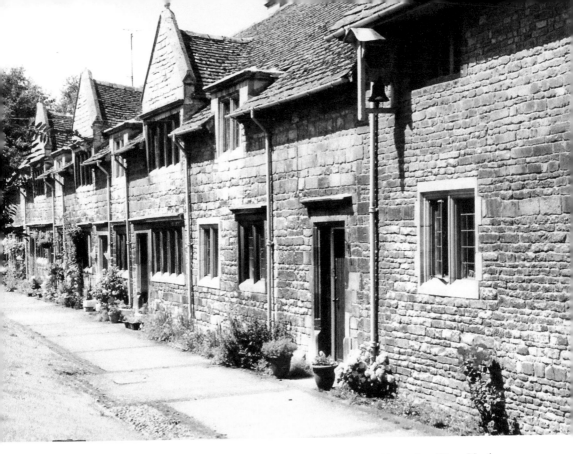

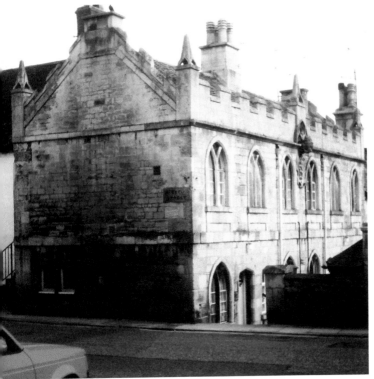

Above: Lord Burghley's Hospital, Station Road. The hospital began life as the Hospital of St Thomas and St John, c. 1170. The hospital was purchased by William Cecil after the dissolution and was formally endowed as Lord Burghley's Hospital in 1597.

Left: Hopkin's Hospital, St Peter's Street. Although named after the mayor, this hospital was founded by public subscription in 1770.

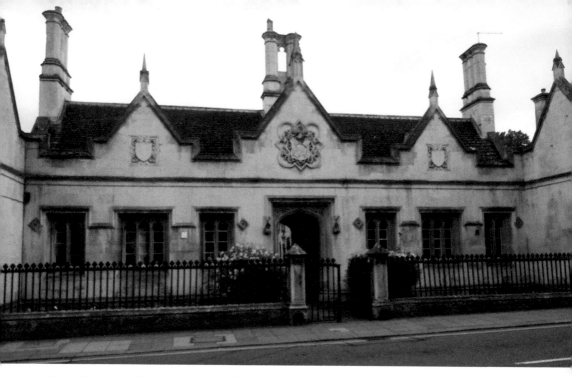

Above: Truesdales Hospital, Scotgate, founded in 1700 under the will of Thomas Truesdale. The present building dates from 1833 and was designed by George Basevi.

Below: St Peter's Callis sits at the junction of All Saints Street and St Peter's Hill. The original building was demolished in 1862 and rebuilt by James Richardson in 1863. It is no longer in use as an almshouse.

commercial purposes. Standing next door to Snowden's Hospital is the much grander building of Truesdale's Hospital. Still in use as an almshouse, it was founded under the will of Thomas Truesdale, a local attorney, in 1700. It was originally intended to house six poor men, but this was increased to eight men plus a nurse in1831.

Other buildings which were once almshouses include St Peter's (or All Saints) Callis, which stands at the corner of All Saints Street and Sheepmarket. The present building dates from 1863 and replaced a late medieval building. Further along St Peter's Street is Williamson's Hospital. Founded by George Williamson, a local grocer, in 1763, this hospital originally accommodated six poor widows but, in 1769, a rear range was constructed to increase the accommodation to eleven. This is now a private house.

Assembly Rooms

During the eighteenth century, Stamford emerged as the social centre for the surrounding area and, prior to 1727, monthly assemblies were held at a house in Barn Hill. The Assembly Rooms, in St George's Square, were built by Askew Kirk, a dancing master, in *c.* 1727. Although they are now incorporated into the Arts Centre complex, it is not difficult to recognise the original layout of the Assembly Rooms, which consisted of the assembly room itself with card and tea rooms on the west side which were added in 1793-4.

The Assembly Rooms, built in 1727 as a dancing academy.

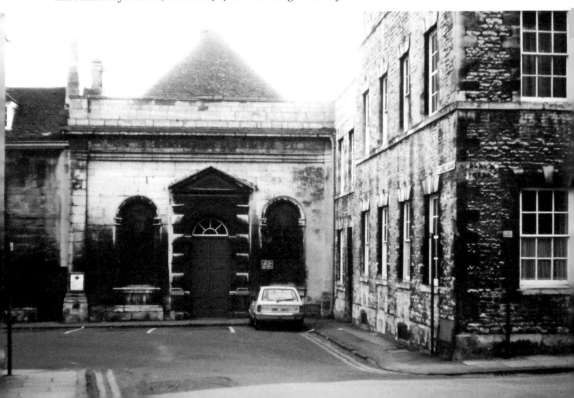

B

Broad Street

Broad street, more than any other, marks Stamford out as a market centre, rather than having grown in a linear fashion along the Great North Road. Any lingering doubts about this are dispelled when one realises that streets on an east-west axis are wide, while those on a north-south axis are comparatively narrow. Broad Street lies north of the Danish burh. Originally open at its east and west ends, the street is now almost enclosed by buildings at the east end and terminates at Star Lane on the west. Star Lane was formerly very narrow, and was widened in the nineteenth century. Today, the street is a mixture of eighteenth-, nineteenth- and twentieth-century buildings.

Markets have been held in Broad Street from an early date. The Beastmarket, which was originally held at the west end of the street, was in existence by 1595. However, this appears to have moved to the east end of the street in the seventeenth century. A cattle market was held in Broad Street until 1887, after which it moved to a site near the Midland railway station. The east end of the street became known as the Haymarket sometime in the eighteenth century.

In front of Browne's Hospital there was the Friday market. Based on the fact that they were both held in front of Browne's Hospital, it has been assumed that the Friday market was the market that by the nineteenth century had become known as the corn market. Interestingly, Burton states that the corn market was established in 972, but does not indicate a source for the date. We can assume that he was basing the date on the fact that King Edgar granted Stamford the privilege of holding markets in that year.

In 1839 the slope in front of the hospital was levelled and a new market, designed in a Tudor style, was built against the hospital wall. The corn market eventually moved across the street into a new building designed by Edward Browning in 1859. Although Broad Street was an important market area, other markets were held elsewhere in the town. The sheep market was, until 1782, held in Barn Hill. The market for butter, poultry haberdashery etc. was held in Red Lion Square. The market for vegetables was held in Ironmonger Street. The butcher's shambles was originally outside St Michael's Church but was then relocated to the Portico (now the library) and stretched from High Street back to Broad Street.

Over the years, Broad Street had something like nine public houses, many of which changed their names over the years. These included, amongst others, the Horns and Blue Boar, the Dolphin (which stood on the site of the RC schoolroom), the Stag and Pheasant, the Rising Sun (now the Lord Burghley), the Roebuck, and the Lincolnshire Poacher.

In 1843, Thomas Charles Gibson started his engineering business at the junction of Broad Street and Star Lane. The site is now occupied by the Hanover Court housing complex. The company were variously described as 'agricultural implement makers, engineers, millwrights and iron and brass founders'. The company continued to trade as engineers and ferrous and non-ferrous founders until Thomas Gibson died in 1924. After that date, work seems to have concentrated on the foundry side. The company finally closed in November 1971.

Broad Street. This street more than any other points to Stamford having developed as a market centre, rather than developing in a linear fashion along the Great North Road.

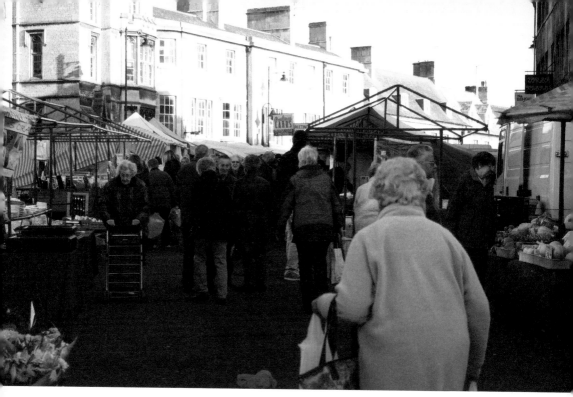

Above: The Friday market of today is the last of a long line of markets once held in Broad Street.

Below: Setting up the Friday market.

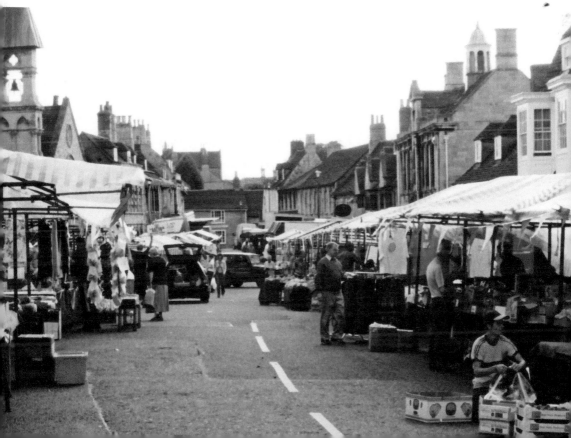

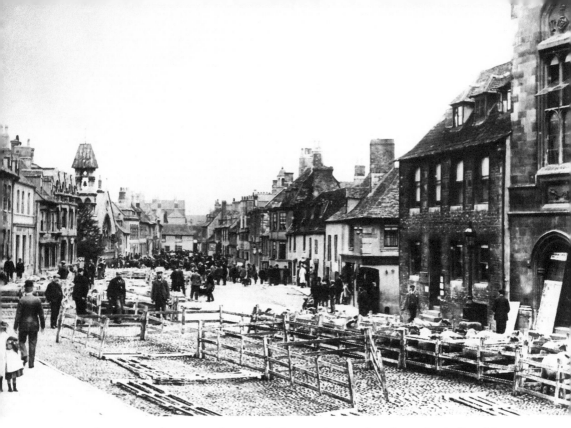

Above: This nineteenth-century photograph shows a sheep and cattle market in Broad Street.

Below: The site of the former Gibson's Iron Foundry in Broad Street.

Browne's Hospital

Browne's Hospital stands in a prominent position on the north side of Broad Street, and can reasonably be said to be one of the best examples of a medieval almshouse in England. The founder of the hospital was William Browne, a wealthy wool merchant, of the Staple of Calais. He was active in civic life and served as Alderman (i.e. mayor) no less than six times. With his brother, he was largely responsible for the alterations to All Saints Church. The memorials of many members of the Browne family, including that of William Browne and his wife, Margaret, are to be found in All Saints.

Browne died in 1489, but fourteen years before his death he conceived the idea of establishing an almshouse in Stamford. The site he chose for this was on high ground (then known as Claymount) just inside the north wall of the town. According to records now in the Bodleian Library, the hospital was completed by 1475/6. However, it was not until 27 January 1485 that Browne was authorised by letter patent of Richard III to found and endow the almshouse. After William Browne's death in 1489, management

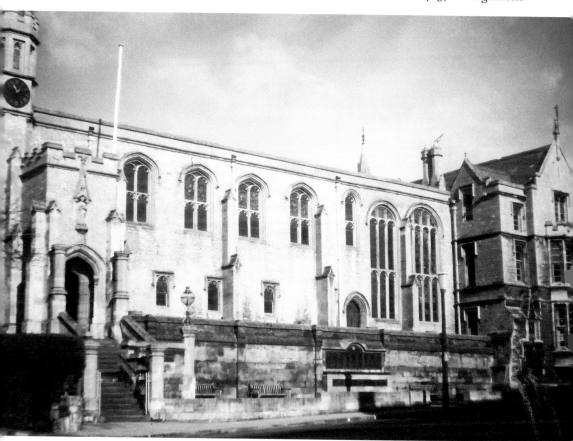

Browne's Hospital, possibly one of the best-surviving medieval almshouses in the country. The building was completed in 1475 and the charity formally endowed in 1493.

The inner courtyard of Browne's Hospital.

of the hospital passed to the brother of Margaret Browne, Thomas Stokke, a canon of York and rector of Easton on the Hill. Stokke obtained fresh letters patent for the foundation from Henry VII in 1493. He also arranged for the consecration of the chapel by the Bishop of Lincoln, and this was carried out on 22 December 1494. The chapel is at the east end of the almshouse, and contains some excellent examples of stained glass, screens and stalls.

At its inception, Browne's Hospital accommodated ten poor men and two women under the supervision of a warden and confrater. The inmates were accommodated in cubicles in a dormitory on the ground floor which was linked to the chapel. The Audit Room was above the dormitory. Harrod records that the chapel was 'beautified' at some point between 1769 and 1785. The porch through which visitors enter the almshouse was rebuilt in 1808. In 1869, due the poor state of the buildings, the Governors requested James Fowler of Louth to prepare a scheme of restoration and improvement. The work was begun in 1870 and was completed late in 1871. The main building was repaired with the west end being rebuilt, and provided with a turret under a cupola to house the clock and bell. The entire site north of the

main building was cleared and the present row of two-storey buildings to house the almspeople were built to the north and east of an enlarged quadrangle. The original Common Room, no longer needed as a dormitory, was opened up by the removal of the partitions to create a useful space which is now often used for meetings of exhibitions. Before the alterations of 1870, the corn market was held immediately in front of the hospital. This was removed and the seven arches that formed part of front and side of the market were reused elsewhere in the town. One can still be seen at the entrance to Star Lane chapel and another at the entrance to the Old Bluecoat School in St Peter's Street.

Bull Running

Bull Running was not peculiar to Stamford, as it certainly took place in some other English towns. There are various accounts of how bull running originated in Stamford, but the most common version suggests that it was instituted by Earl Warrene. As local

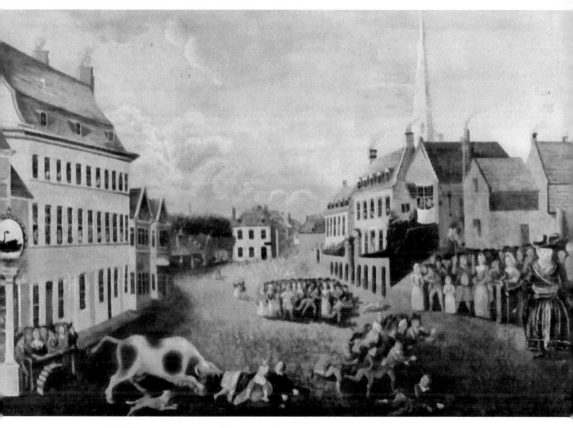

A painting of bull running in Broad Street. This painting, by an unknown artist, dates from c. 1800. It is reproduced here by kind permission of Stamford Town Council.

legend has it, Earl Warrene, when standing at a window of the castle, observed two bulls on the meadow fighting over one cow. The local butchers came with their dogs to part them, which they did, but the bulls being enraged ran into the town causing mayhem. The earl took to his horse and rode into the town and joined the mob chasing the bulls. The earl was so pleased with the sport, that he gave the ground on which the fight took place to the butchers on condition that they should find a mad bull to run in the town on 13 November every year.

As with many legends, there is probably a grain of truth in there somewhere, but with no definitive record, it is difficult to tell. Bull-baiting was not peculiar to Stamford and various forms of the sport were carried out, notably in London and Tutbury. In Stamford however, it persisted far longer than elsewhere in the country. Bull-baiting in Tutbury was stopped by the Duke of Devonshire in 1788 – interestingly, the same year that the first attempt was made to bring it to an end in Stamford. By the early nineteenth century, attitudes to the sport (if it can be called that) had begun to change, not only because it was seen as a public nuisance, but also because of changing attitudes to animal cruelty.

A bill introduced into the House of Commons in 1802 to ban bull-baiting was defeated and it was another thirty-three years before it was finally outlawed by the Cruelty to Animals Act of 1835. The RSPCA had campaigned to stop the Stamford run in 1833, but without success. In March 1837, the ringleaders of the previous year's bull run were indicted for disturbing the peace and running a bull. The defendants were found guilty, but this did not, in any way, lessen the determination to run a bull again. In November 1837 some 200 special constables were sworn in and troops were brought in to stop the bull run, which happened anyway!

Stamford's last bull run was in 1839, when an even larger force of soldiers, together with constables from the Metropolitan Police, were brought in to stop the run. In the end, it was the cost of the police and military that put a stop to the bull run. The people of Stamford had been forced to bear the cost of the militia presence for several years in a row (in 1839 the cost was £300), something that they could ill afford, so they agreed to stop the practice.

C

Coaching

Stamford's resurgence in the late seventeenth and eighteenth centuries owes much to the establishment of Turnpike Trusts and the subsequent growth in coaching activity. Although the eighteenth century saw a dramatic rise in coach travel, there had been regular coach services between London and Stamford since at least 1685. At that time the journey from the George Inn at Aldersgate to Stamford took two days and cost 20 shillings. Improvements in the roads produced by the Turnpike Trusts made it possible for coaches to be used more extensively and for most of the year. By 1769 it was possible to travel from Stamford to London (via Royston) in a day. In 1792 the 'Original Stamford Fly' regularly did Stamford to London in sixteen hours.

Coaches were generally of two types: mail and stage. Mail coaches ran to a very strict timetable, and carried up to four passengers inside, although after 1803 extra passengers were allowed to travel outside. Stagecoaches, on the other hand, usually carried a maximum of four passengers inside and anything up to ten passengers outside; one of these would sit next to the coachman. The year 1830 was the peak year for coaching in Stamford with forty mail and thirty stagecoaches passing through the town each day. By 1832, roads had improved sufficiently for the 402-mile journey from London to Edinburgh to be accomplished by 'flying coach' in forty-two hours thirty-two minutes.

The growth in coaching saw an increase in the need for stabling and accommodation, and consequently an increase in coaching inns. Existing inns such as the George, the *George and Angel* and the *Bull* adapted to meet the new demand. The frontage of the George was completely rebuilt by the Cecils in 1724. Changes to a number of other inns can be dated to this period including the Bull and Swan (then the Falcon and Woolpack) and the Coach and Horses. In addition, of course, there was a growth in the need for those trades that regularly worked with horses, such as ostlers, farriers and wheelwrights. Similarly, a growth in the number of travellers saw a growth in the infrastructure needed to meet their needs.

At certain times of the day, the staff at the various coaching inns would have been extremely busy. The Edinburgh mail arrived in Stamford from London at 6.15 a.m. and left for the north half an hour later. The coach doing the journey south reached

Stamford at 7.30 p.m. and was on its way to London by 8 p.m. The Glasgow mail arrived in Stamford from London at 6.30 a.m. and resumed its northward journey within twenty-five minutes. The journey south had an even faster turnaround, the coach arriving in Stamford at 11 a.m. and departing by 11.15 a.m. A cross-country mail between Yarmouth and Leicester began in June 1822. This too was timed to reach Stamford from Yarmouth at 6 a.m. in order to meet with the Edinburgh and Glasgow mails. The Yarmouth mail departed Stamford for Leicester, via Oakham and Melton, at 7 a.m., taking with it post it had collected from the Edinburgh and Glasgow coaches. The Yarmouth coach reached Stamford on its return journey at 7 p.m., again, in time to meet with coaches going north and south

Coat of Arms

The arms of the former Borough of Stamford (the town lost its Borough status in 1974) were probably granted during the time of John, Earl de Warrene. The blue and gold chequers are those of the Earls Warrene, who held the manor in the thirteenth century. The three gold lions on a red background were possibly used to indicate that the town was a royal borough.

The official blazon (i.e. description) reads, 'Party per pale dexter side Gules three lions passant guardian in pale Or and the sinister side chequy Or and Azure'.

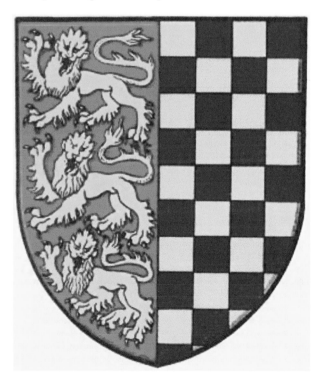

The arms of the former Borough of Stamford.

D

Danelaw

By the late ninth century, the Vikings had overrun most of the Anglo-Saxon kingdoms that constituted England at that time. However, Alfred the Great (King of Wessex) defeated the Vikings at the Battle of Edington in 878. The treaty that resulted from this encounter gave the Danes control of north and eastern England, with Alfred controlling Wessex. The area controlled by the Danes was north-east of a line roughly from London to Liverpool. In this area Danish legal and social customs prevailed until the Norman Conquest. Stamford was important at this time being one of the five boroughs, the others being Derby, Leicester, Lincoln and Nottingham. These were the bases for the five Viking armies during the reign of Alfred, and possibly the most heavily Danish-settled parts of the Danelaw. Danish place names proliferate in the area, for example Langtoft, Wilsthorpe, Obthorpe and Thurlby.

Domesday Book

In 1086, Royal Commissioners visited Stamford to carry out a survey on behalf of the king. So what can the Domesday survey tell us about eleventh-century Stamford? Well firstly, we are made aware that Stamford is regarded as a royal borough as the town's entry is headed Stanford Burgum Regis. From the figures given, we can deduce that the town's population was between 2,000 and 3,000, and the names given suggest a mixed in population, both English and Danes sharing in the local economy. The survey also tells us that some of the most important people in the land held property in the town. These included Edward the Confessor's Queen, Edith who, together with Hamilton in Rutland, held an estate in Stamford consisting of several houses and St Peter's Church. Countess Judith, the niece of the King, also held a number of houses together with land. We also learn that the Abbot of Peterborough had significant holdings in the town. The chief men in the town were the Danish 'lawmen', a group of property owners who, as Alan Rogers points out in *The Book of Stamford*, 'interpreted, preserved and passed on the borough customs'. We know that the castle is in existence at this point, since the survey tells us that five houses were

demolished to make way for it. It is interesting to note that Stamford was one of the very few non-county towns in which William chose to establish a castle. This may tell us something about the town's importance at the time. In the five wards north of the river there were 412 houses. No figures were given for St Martin's as technically that part of the town belonged to Peterborough. The survey refers to St Martin's as being beyond the bridge, so we know that there was a bridge in existence at that time. Four churches are mentioned; the first of these is clearly St Peters, as it is mentioned by name. All Saints seems likely to have been one of the others. Given that the other two were likely to have been within the area of the Danish burh, this suggests that St George's and St Michael's were possibly early foundations.

Elections

Stamford was a prime example of what became known as a 'pocket' borough. The town had two members of parliament and, until 1698, the town was variously represented by members of the local aristocracy or squirarchy. These included the Berties, Hatchers, Winfields and Custs. After 1698, the influence of John, 5th Earl of Exeter, began to bear sway in the town. It was in that year that William Cecil (younger son of the 5th Earl) was elected alongside Charles Bertie. From then on, until 1727, one Cecil and one Bertie (or Noel) always shared the two seats. The Cecil and Cust families were opposed to each other until 1734, when the decisive political battle was fought and won by what became known as the Cecil/Noel confederacy. Thereafter, with only two exceptions between 1734 and 1874 (when the borough was disfranchised), all members of parliament for Stamford were nominated by the earls or marquesses of Exeter. Furthermore, between 1734 and 1809, a period of seventy-five years, and between 1847 and 1874 (twenty-seven years) there were no election contests in the town. In the whole of the nineteenth century only ten contests were fought and in only eight cases did the voters actually go to the poll.

Stamford's notoriety as a pocket borough was so great that it was frequently held up as an example of all that was corrupt in nineteenth-century politics. For example, the Tithe Commissioner wrote in 1839 [Lord Exeter's control of Stamford is] 'a state of barbarous intervention and blindness, which resembles more an African domination than an English and wholesome interference'. Twenty-nine years later, in 1868, the Reform League Report said, 'For years past Stamford has been a pocket borough belonging to the Marquis of Exeter, who lives close to the town and owns a great portion of it. There are no manufacturers in the place except a small firm who make agricultural implements, and the tradespeople depend on the surrounding gentry for their custom, so there is no independence in the place. Everything in the shape of a Liberal organisation has completely died out.'

Opponents of the Cecils believed that the only way to challenge their influence was to create an estate in the town in which to house people who were not dependent on Lord Exeter. Sir Gerard Noel and Richard Newcombe both exhausted their resources in a vain attempt to do this. In 1810, Noel began building the Stamford Hotel which,

for a time, became the political headquarters of the Whigs. However, following his defeat in the election of 1812, Noel appears to have abandoned the cause. Before the Reform Act of 1832 the right of election was in the inhabitants paying scot and lot, a local tax, and the estimated number of voters was 500. Paradoxically, the Reform Act replaced scot and lot with an occupation franchise. This actually reduced the number of voters because the value of property (occupation of which conferred a vote) was higher than that for houses on which scot and lot was payable. Under the Reform Act of 1867, the town's number of MPs was reduced to one.

The area was strongly Tory in politics and between 1801 and 1918 on only two occasions were candidates from other parties elected: a Whig in 1831 and a Liberal in 1880. In the nineteenth century, the borough MPs included some notable names including the Marquess of Granby (1837–47) Lord Robert Cecil (1853–68) and Sir Stafford Northcote (1858–66). The notoriety of Stamford's elections was such that in May 1831 two Russian noblemen were advised to go and observe the parliamentary election, as it would provide them with an illustration of 'the greatest battle between the aristocracy and the people'. The Redistribution of Seats Act 1885 abolished the borough constituency, and the name was absorbed into a county division. Thus, the situation remained until the 1918 Representation of the People Act when Stamford was combined with the county of Rutland in a new Rutland and Stamford constituency. Further changes were, however, to come. In 1983 a new constituency with Grantham, Stamford and Spalding was created and this remained in place until 1997 when the Grantham and Stamford constituency came into being.

Enclosure

Stamford's townscape owes a great deal to the fact that the enclosure of the open fields to the north of the town did not take place until 1871. Any attempt at enclosure before this was vigorously opposed by Lord Exeter, as part of his strategy to preserve his political monopoly. St Martin's, which was almost wholly owned by Lord Exeter, was enclosed much earlier in 1795.

F

Fairs

A number of fairs were held in Stamford during the course of the year. They were clearly well known throughout the country and Shakespeare has Robert Shallow asking 'How a good yoke of bullocks at Stamford fair?' (Henry IV, part 2) The fairs began with the Candlemas fair for beasts and horses and this was held on the Tuesday before 13 February. The mid-Lent fair came next; the first part of the mid-Lent fair was for horses, beasts and sheep with the remainder of the week being given over to

The modern mid-Lent street fair is the last vestige of a tradition of fairs that can be traced back to the medieval period. The Stamford street fair is the largest in the county, and may even be the largest in the country.

haberdashery, toys and amusements. From 1845 there was a spring fair for beasts and sheep; this was held on a Tuesday as decided by the mayor. On the Monday before 12 May there was the May fair for horses beasts and sheep. The Corpus Christi fair was held on the Monday after Corpus Christi and this was for horses and beasts. The last big fair of the year was the St Simon and St Jude fair held in November. Initially this was held on only one day (8 November) but after 1820 the Corporation ordered that it should be held on two days. The 8 November was given over to horses and sheep and 9 November for beasts. The fairs were an important aspect of the local and regional economy and it is interesting to note that the fairs continued throughout the English Civil War when it would have been logical for Parliament to ban them, since they provided an opportunity for people to gather in large numbers. In fact, Parliament capitalised on the situation, and Lieutenant Russell, the Eastern Association's agent for purchasing horses, frequently bought horses from Stamford fairs and markets.

The present mid-Lent fun fair is the last remnant of this long-standing tradition of fairs. The Stamford mid-Lent fair is the largest street fair in Lincolnshire and possibly one of the largest in the country.

Friaries

During the first half of the thirteenth century friars of the mendicant orders reached Lincolnshire, possibly in the wake of Robert Grosseteste. Dorothy Owen pointed out in *Church and Society in Medieval Lincolnshire* that 'they generally settled in towns where their infectious evangelical zeal attracted many penitents and much lay enthusiasm'.

Stamford attracted all four of the major orders which, in itself, is unusual as even larger towns such as Leicester and Chester usually only attracted one or two. The orders that came to Stamford settled outside the town walls and erected substantial buildings. The Carmelites (White Friars) and Franciscans (Grey Friars) both established themselves to the east off the town. The Franciscan friary was large and attracted substantial endowments, amongst which was a 'sumptuous chapel' founded by Joan, widow of the Black Prince. Blanche Lady wake, daughter of the earl of Lancaster was buried here.

There has been some confusion about the location of the Greyfriars in Stamford, particularly among earlier historians. John Drakard in his *History of Stamford* (1822) puts the White Friary 'where the road divides for Ryhall and Uffington'. However, later evidence suggests that it was the Grey Friary that occupied the site that now houses the Stamford Hospital complex. The confusion arises because the medieval gateway into the Grey Friars site has been traditionally known as White Friars. It seems more likely that the White Friary was located nearer to the town on a site between St Paul's Street and St Leonard's Street and that it was the Greyfriars that occupied what is now the hospital site.

The Dominicans (Black Friars) were in existence in Stamford by 1241, and settled to the south-east between St Leonard's Priory and St George's gate on land on which, in the nineteenth century, the gasworks were built. This was also an important house and the provincial chapter of the Black Friars was held here on several occasions. The Friars of the Sack occupied a site just outside St Peter's gate opposite what is now Rutland Terrace. Sometime after the order was suppressed in 1274, the house was taken over by the Austin Friars. The Austin Friary was established in 1342 by Robert de Wodehouse, Archdeacon of Richmond and king's clerk.

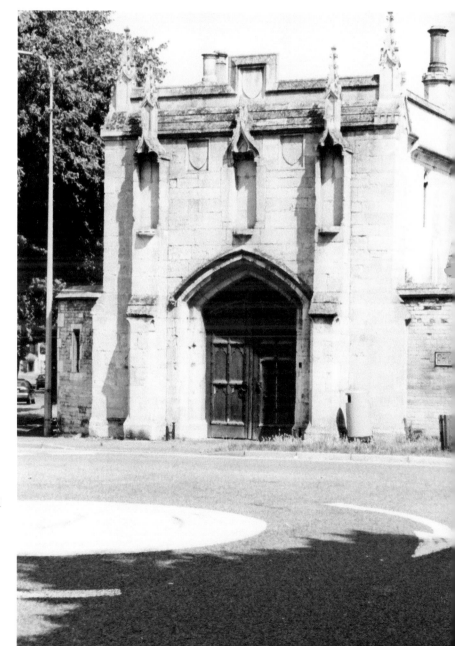

White Friars gate. Although locally referred to as White Friars, this was actually the gate into the Franciscan (Grey) friary.

Gaol

When the new Town Hall was completed in 1779, it incorporated the town gaol. The cells in the gaol were 10 feet by 8 feet and 7 feet high. Each cell had a small window just 2 feet 5 inches square. The walls dripped with water in wet weather and the sanitary

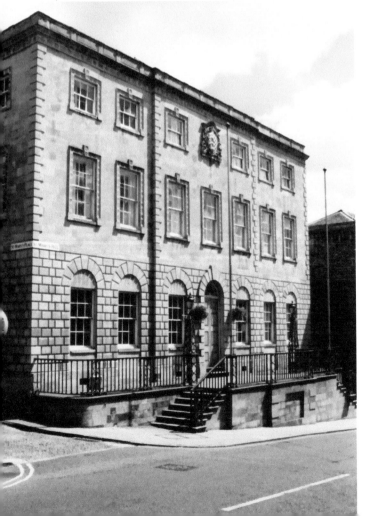

The Town Hall. The present building dates from 1779 and replaced an earlier Town Hall in rooms over the bridge gateway.

conditions were said to be appalling. Towards the end of the eighteenth century, conditions in the gaol were so bad that it was said to be 'the worst in the kingdom'. In 1822 the Corporation took the decision to build a new gaol, which they did, at a cost of £2,500, which was paid for out of the poor rate over a fourteen-year period. Incorporated was an exercise yard and a treadmill.

In 1844, alterations to this new building were carried out by order of the Secretary of State.

Across the river in St Martin's a small lock-up was maintained for the short-term detention of prisoners.

Grey, Henry, 1st Earl of Stamford (1599–1673)

Henry Grey was known as Lord Grey of Groby between 1614 and 1628. He was the eldest son of Sir John Grey and Elizabeth Nevill. He succeeded his paternal grandfather as the 2nd Baron Grey of Groby in 1614. He was a long-standing opponent of the Hastings family in Leicestershire. Through his marriage to Lady Anne Cecil, daughter of William Cecil, 2nd Earl of Exeter, he obtained the manor of Stamford as part of the marriage settlement. In March 1628 he was created Earl and took Stamford as his title. He fought with the royal army in the Bishops' Wars against the Scots in 1638/9. However, as a committed Puritan, Grey (or Stamford as we should now call him)

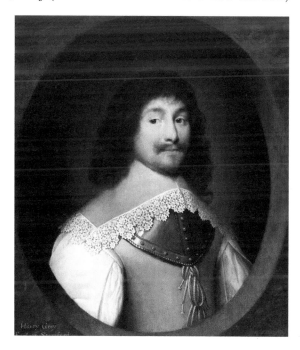

Henry Grey, 1st Earl of Stamford.

supported Parliament in the build-up to the Civil War. He was appointed Lord Lieutenant of Leicestershire by Parliament in 1642. However, when the king's army approached Leicester, Grey left the city and went to London, where he was appointed a colonel in the army of the Earl of Essex – a surprising appointment since the Earl of Stamford did not have the military experience that many of his contemporaries did. In October 1642 he was appointed governor of Hereford. His tenure in Hereford was, however, short-lived, as the mainly Royalist populace would not co-operate with him. He subsequently withdrew to Bristol, and in the early part of 1643 was given command of the Parliamentary army in Devon. Stamford advanced into Cornwall in May 1643 and had some early successes against the Royalist army. However, he was decisively defeated by Sir Ralph Hopton's army at the Battle of Stratton in May 1643. Following his defeat, Stamford fled to Exeter. However, he surrendered Exeter to Prince Maurice's besieging force in September 1643. He returned to London, where he attempted to blame his military failures on those serving under him.

Stamford sat as MP for Leicestershire in the First Protectorate Parliament of 1654, but became increasingly disenchanted with the Protectorate regime. At the Restoration, he was pardoned for his part in the First Civil War. He died in 1673. The manorial rights which had been acquired by Henry Grey on his marriage were reacquired by the 8th Earl of Exeter in 1747.

The title of Earl of Stamford, and that of Baron Grey of Groby, became extinct on the death of the 10th Earl in 1976.

H

High Street

The High Street was the axial road of the Danish burgh. In the past, it has been variously known as Colegate and St Michael's Street. It has always been a street of some importance and, since the eighteenth century, has developed into the main commercial area of the town. Many of the buildings were altered during the eighteenth and nineteenth centuries to suit the needs of the time and, of course, this process goes on. To get a feel for what the street might have been like in earlier times, one needs to look above ground-floor level – something we rarely do when shopping in the town. Walking the street in the early morning or late evening will provide

A nineteenth-century view of High Street.

those interested with some excellent eighteenth- and nineteenth-century façades. In addition, note the front of Gothic House, refronted in 1849 in the revived Tudor style. A little further along the street there is an excellent nineteenth-century shopfront at No. 7 High Street.

High Street, St Martin's

This street was probably developed from the axial road of Edward the Elder's Saxon borough established in 918. During the Middle Ages the street was known as Highgate. This has, of course, been the main entry route into Stamford from the south for

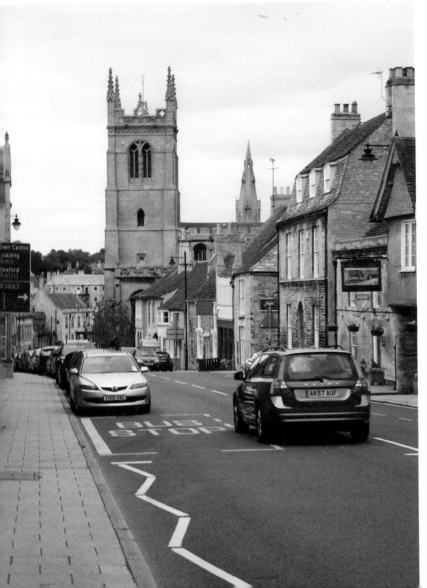

A general view of High Street, St Martin's. The upper part of the street was mainly residential, with commercial premises being located below St Martin's Church.

many years. Prior to this it is probable that the route from the south into Stamford followed Wothorpe Road, and across the meadows. Equally probable is a route down the present Park Lane to the ford on Water Street.

Then, as now, the northern end of the street was the commercial end. Although they have declined in recent years, there were a number of shops at this end of the street. The southern end of the street was formerly known as Spital Hill. This name probably derives from the medieval leper hospital of St Giles, which was founded sometime before 1189.

During the eighteenth century, the southern end of the street became more residential, with houses occupied by professional and well-to-do people. Samuel Sharp noted in 1847 that 'St Martin's may be called the aristocratic district of Stamford, containing few shops and chiefly residences of those who have not worked with their hands.'

It is an interesting aspect of Stamford's history that the Enclosure Act for St Martin's was enacted in 1796, almost eighty years before the open fields to the north of Stamford were enclosed. The reasons for this are that it was part of a deliberate strategy to preserve the Cecils' political monopoly. However, the enclosure of St Martin's made it possible to create Kettering Road. Before then the route from Easton into Stamford would have been via Church Lane and Church Street. Barnack Road was also created after the Enclosure Act.

Hotels

Stamford has never had a shortage of inns and hotels, but two stand out from the others as worthy of comment. Arguably, the most well known is the George Hotel. The George Inn, as it was then known, was in existence by 1568 when Andrew Scarre was granted a licence to sell wine there. The earliest part of the hotel is the east range, which dates from around 1600. It was refaced by George Portwood in 1724. Further improvements were carried out by the Earl of Exeter in the last quarter of the eighteenth century. These included new stables and the rebuilding of the north wing. The south range was rebuilt in 1792. In 1725, George Portwood had constructed an octagonal cockpit at the hotel, and this was removed when Station Road was created in 1849. Alterations carried out in 1850 included a new carriage entrance in the north wing. The George rose to pre-eminence as a coaching inn, something that is still reflected today as one enters the main door – the waiting rooms for London and York are on the left and right, respectively. The George was also a favoured meeting place for sportsmen, particularly during the Stamford races. It also provided the focal point for a number of other local organisations including the quaintly named Stamford Association for the Prosecution of Felons, who held their annual meeting and dinner at the George.

During its long history, the George has played host to many famous people, including royalty. Charles I stayed there in 1641 and 1645 and William III in 1696. The Duke of

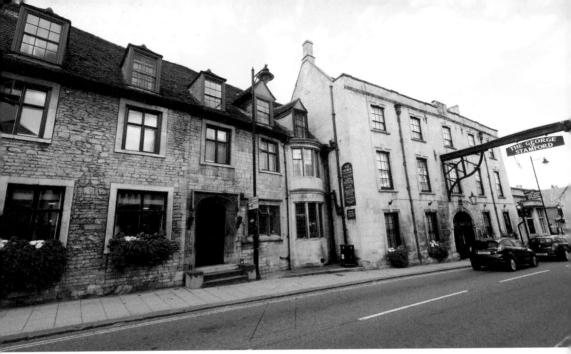

Above: The George Hotel. The hotel has been in existence since at least 1568. The hotel was refronted by George Portwood in 1724.

Left: The William Cecil Hotel, formerly known as Lady Anne's Hotel.

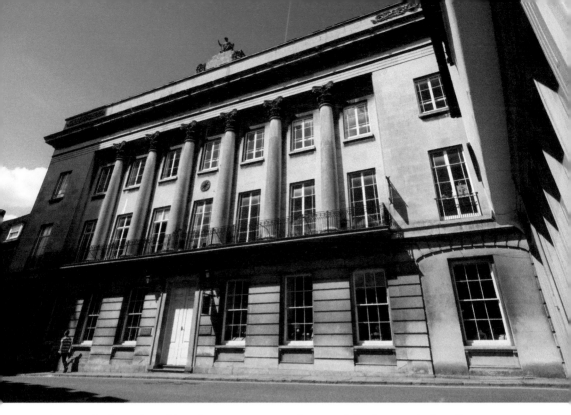

The Stamford Hotel. Building began in 1810, on the site of the former Black Bull Inn, parts of which were incorporated into the new building. The hotel was designed by the London architect J. L. Bond.

Cumberland also stayed there in 1746 on his way back to London following the Battle of Culloden. Out of curiosity, the author Daniel Defoe stopped there in 1724 because 'it is reckoned one of the best inns in England'.

The Stamford Hotel has a very different, but no less interesting, history to that of the George. It was built by Sir Gerard Noel as part of his political campaign to attract political and electoral support against Lord Exeter. The hotel became the political headquarters of the Whigs. It was built in St Mary's street, on the site of the Black Bull Inn, and parts of the former inn were incorporated into the new hotel. Building began in 1810, to a design by the architect J. L. Bond, of London. Noel clearly set out to make a statement, creating a hotel some three storeys high and nine bays long, its grandeur emphasised by seven large Corinthian columns. The whole frontage surmounted by a seated classical figure of Justice, said to be by John C. F. Rossi. It was, at the time, the largest secular building in the town. Most of the ashlar used in the hotel's construction came from Noel's own quarries at Ketton. At its completion, the hotel had cost £43,000, the main expense of which was borne by Sir Gerard Noel. In 1813, work was sufficiently advanced for Noel to give a dinner for his election committee. However, work on the hotel ceased around this time due to Noel's defeat in the election of 1812, and the hotel remained empty until 1825 when it was leased to Thomas Standwell. As the *Stamford Mercury* of 12 August 1825 reported, it was opened to 'accommodate families of highest distinction in superior style'.

In 1845 the hotel was sold and further improvements were made. Following a chequered history as a hotel, it finally closed and stood empty for some years. In 1983, it became the Stamford Walk shopping centre.

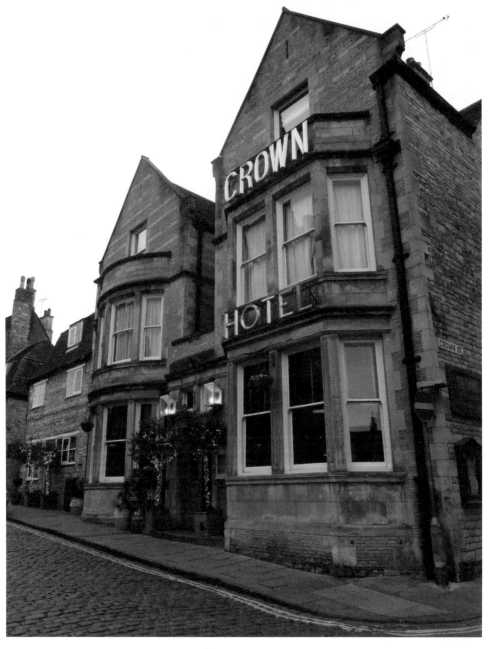

The Crown Hotel, All Saints Place. There has been a hotel on this site since at least the seventeenth century, and possibly earlier. The present building dates from 1909.

I

Infirmary

The Stamford and Rutland Infirmary owes its existence to local surgeon Henry Fryer who, in 1823, bequeathed the sum of £7,477 for the founding of an infirmary, providing it was built within five years of his death. A number of architects were invited to submit designs for a 'building to contain not less than 20 patients and be capable of

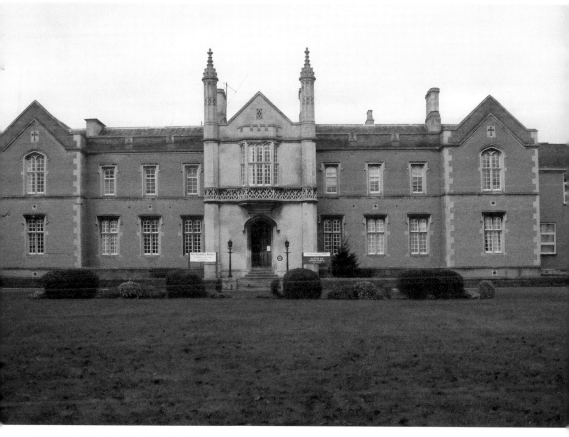

The Stamford and Rutland Infirmary.

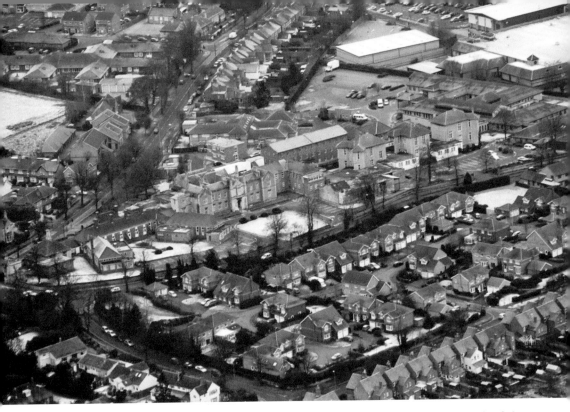

Stamford hospital from the air. White Friars gate can be seen on the extreme left of the photograph.

conveniently accommodating 32 if necessary'. It was rumoured at the time that the architects were instructed to design the building in such a way that if the charity failed, it could easily be turned into a private house. There may be some truth in this since, if one views the original buildings from the front, and ignores the modern extensions, it very much resembles a large country house. The design chosen was that submitted by J. P. Gandy and the infirmary was duly built and opened on 5 August 1828.

In 1844, a fever ward was added to the original building. Additions to the hospital have continued piecemeal almost to the present day. In 1879, the fever blocks were erected to the east of the main building at a cost of £7,025. Although treatment in the hospital was free, the process of gaining admission as a patient was not easy. Prospective patients needed a nomination from a subscriber to the charity in order to be admitted. Subscribers to the charity were able to nominate in- or out-patients according to the level of their personal contribution; for example, subscribers of one guinea a year would be entitled to recommend two out-patients a year. This system survived until the foundation of the National Health Service in 1948.

The hospital had grown steadily throughout the nineteenth and twentieth centuries and had become an important part of the local community. However, the perception that large acute hospitals were the way forward, together with centralisation of support services, affected many smaller hospitals, including Stamford, quite badly. The creation of Peterborough District Hospital and, later, Peterborough City Hospital saw many services withdrawn from Stamford and relocated to Peterborough.

The hospital lost its excellent laundry service quite early on and the children's and maternity wards were early casualties of the relocation of medical services. Nevertheless, despite rumours of closure, which saw the people of Stamford taking to the streets in protest, the hospital continues to provide an excellent service to the people of Stamford and the surrounding villages.

Inns

In common with many other towns of similar age, Stamford has generated more than its fair share of myths. One of the most enduring of these relates to the number of pubs in the town. This varies depending on who is telling the story and how much has been drunk! In reality, the maximum number of pubs in the late nineteenth and early twentiethth centuries was probably around fifty – a good number but, given the nature of the town as a market centre, probably no more than other market towns of similar size. The confusion over numbers arises through name changes, given that many pubs changed their name a number of times. Such changes sometimes took place when a pub changed ownership, and often reflected the new owner's trade. Thus, the Engine at No. 11/12 Scotgate was, at different times, known as the Glaziers Arms and the Mechanics Arms. The Jolly Brewer on West Street has also been known as the Brewery Inn and the Brewers Inn. Similarly, the Bull and Swan, in High Street, St Martin's, was known as the Falcon and Woolpack in the late seventeenth century. It then became the Woolpack and, in 1739, is recorded as the Swan and Wool Pocket before becoming the Bull and Swan in around 1740.

The Bull and Swan Inn, High Street, St Martin's.

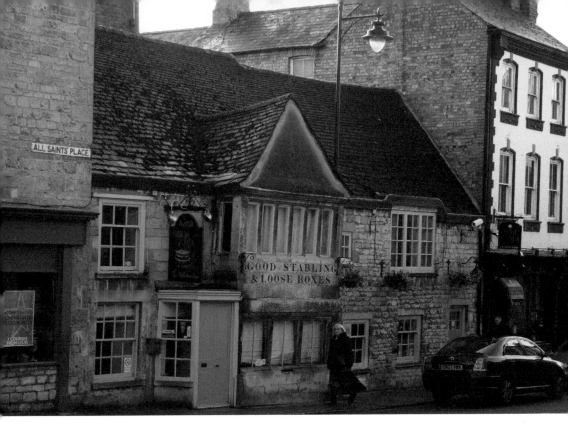

Above: The Millstone Inn, All Saints Street. This inn dates from the late seventeenth century, which is reflected in its gabled bay and mullioned windows.

Below: The former Roebuck Inn, Broad Street. After closing as a public house, the building, for a time, became the home of the *Stamford Mercury*.

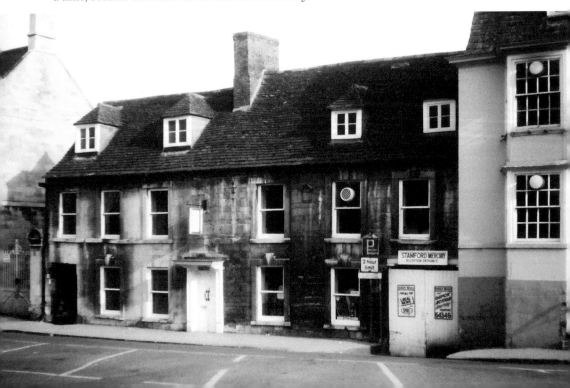

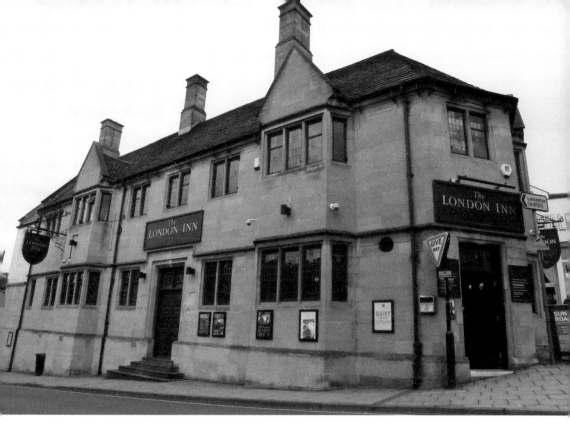

The London Inn was designed by H. F. Traylen and replicates the seventeenth-century Stamford vernacular style of building.

Jacobite Riots

In the spring and summer of 1715, a series of riots broke out in England protesting against the first Hanoverian king of Great Britain, George I, and his new Whig government. The rioters often attacked dissenting chapels, as the Dissenters were allied to the Whigs. Such was the case in Stamford when a mob destroyed the Presbyterian chapel which stood in a yard on the south side of St Paul's Street near the conduit. They carried material away from the chapel and burned it on the Tenter meadow. Several of the rioters were imprisoned, but on the next market day, a rabble from the surrounding villages entered the town and insisted on those in prison being liberated, otherwise they were going to pull the mayor's house down. Faced with this threat, the mayor complied. That night, the pulpit, seats and anything else that could be moved from the chapel were burnt. Among the mob that surrounded the fire was one Roger Dobbes, a zealous Jacobite who, spreading his hands before the fire, called it a 'blessed blaze' and lit his pipe with a splinter from the burning flames. Following this event, a troop of dragoons were stationed in the town to prevent further disturbance.

Jurassic Limestone

Stamford lies on that belt of Jurassic limestone that sweeps in a curve from the north-east of the country to the south-west. The stone quarried locally was a fine grained oolitic limestone, free from fossils, which was quite easily worked with the hand tools of the period. It became known as Stamford or Casterton stone principally because the Stamford quarries and the two quarries in Casterton were virtually the same deposit. Many of Stamford's late seventeenth- and eighteenth-century buildings are faced with this stone. Extensive quarrying was undertaken in the area, mostly to the north-west of the town; however, there were small quarries being used within the boundaries of Stamford. Richard Newcomb's Rock House was, for example, built on the site of a former quarry.

Stamford freestone was not, by any means, the only stone used locally. Close examination of buildings will show the use of Barnack Rag (parts of St Leonard's

Priory), Ketton stone (Stamford Hotel and Barclays Bank), Clapham stone (London Inn), and Wittering Pendle (Bath House and the buildings at the north end of the town bridge).

Right: Stamford Theatre, St Mary's Street, a good example of Stamford freestone.

Below: The former School of Art which, for a number of years, was the home of Stamford Museum. This is another example of local freestone.

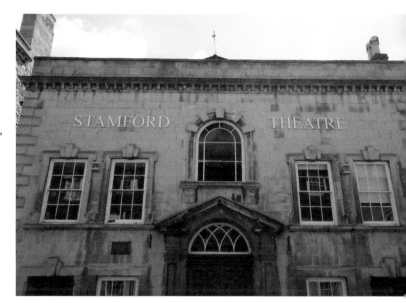

King, Cassandra

Cassandra King was the last person to be condemned to death in Stamford. She was tried for committing a burglary at Wothorpe in 1704. Local legend has it that after her execution proof of her innocence was discovered, and for this reason capital punishment in the town was stopped. However, the story may be more complicated than that. There are a number of puzzling issues about the case. Firstly, why was she tried in Stamford for a crime committed in another county? Why was the sentence passed on her unduly harsh? While burglary was technically a hanging offence (until the death penalty for theft was abolished in 1832), justice in these cases was usually tempered with a degree of mercy. According to Drakard, the harshness of the sentence drew some criticism at the time, with the case being seen as an abuse of power. Thereafter, the Corporation, perhaps wisely, referred similar cases to a higher court. Cassandra King was buried in the north-east corner of St Michael's Churchyard.

Klips Hill

Klips Hill (or Clips) was the original name of Barn Hill. John Drakard suggests that the name derives from the fact that a noble Saxon called Kilpis lived in that area. However, on Speed's map of 1610, it appears as All Hallows Street. In his *Chronology*

Barn Hill from All Saints Place.

of Stamford George Burton puts forward the theory that the present name of Barn Hill derives from the large barn belonging to Alderman Wolf which stood on the site of the present Methodist chapel. Prior to 1782, the sheep market stood at the top of Barn Hill before being moved to Sheepmarket in that year.

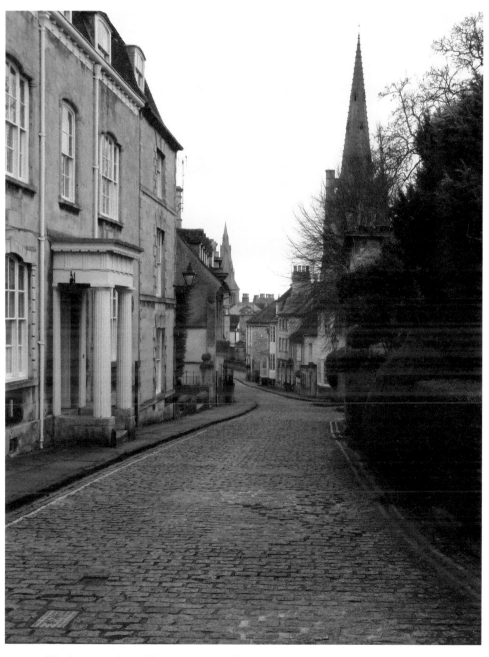

Barn Hill looking south. Stukley House is on the right of the photograph.

Lambert, Daniel

Although Daniel Lambert's name is well known in Stamford, he was, in fact, a native of Leicester, having been born there on 13 March 1770. His father was the keeper of Leicester House of Correction and Daniel, at the age of twenty-one, succeeded to the post when his father retired in 1791. Although he was a physically active man, who did not eat or drink to excess, his weight began to increase, something that he himself put down to his sedentary life at the gaol. By the time the gaol closed in 1805, his weight had grown to 50 stone. Being unemployable, and sensitive to his size, he became, for a time, a recluse. However, poverty forced him to put himself on exhibition in order to raise money. In 1806 he took up residence in London, and charged people to visit him in his apartments, something that became highly fashionable for a few months. In late 1806, tiring of being on public display, he took himself back to Leicester.

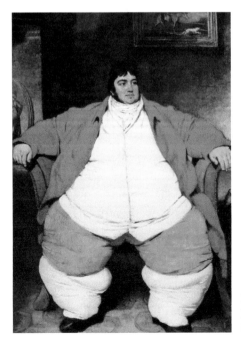

Daniel Lambert, who died in Stamford in 1809. His grave is in the second churchyard, behind St Martin's Church.

Between 1806 and 1809 he undertook a number of fundraising tours. It was on one such tour that he died suddenly in Stamford on 21 June 1809. At the time of his death he weighed 52 stones 11 pounds and had a waist measurement of 9 feet 4 inches. His coffin required 112 square feet of timber and it was reported that it took some twenty men around half an hour to get his coffin into the grave. The grave is in the second churchyard of St Martin's Church.

Lammas and George Bridges

The Lammas Bridge is the second bridge on the meadows which crosses the millstream. The bridge at the other end of the causeway, and which crosses the river, is known as the George Bridge. These two bridges, and the causeway between them, possibly mark the earliest route into the town. In recent years, both of the earlier wooden structures have been replaced with more modern bridges.

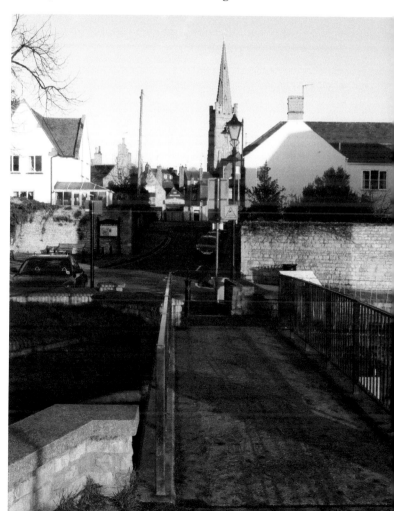

The Lammas Bridge, Bath Row.

Library

The town library is housed in what was once the Portico. The site had been purchased in 1801 by the Borough Council for the new butcher's shambles. The Portico was opened in 1808. Designed by William Legg, the building owes much stylistically to Inigo Jones' St Paul's Church in Covent Garden. The building was, initially, open at the front and the sides. However, these were built up when the building was converted to a library in 1906. For many years, the library also housed the museum collection on its mezzanine floor.

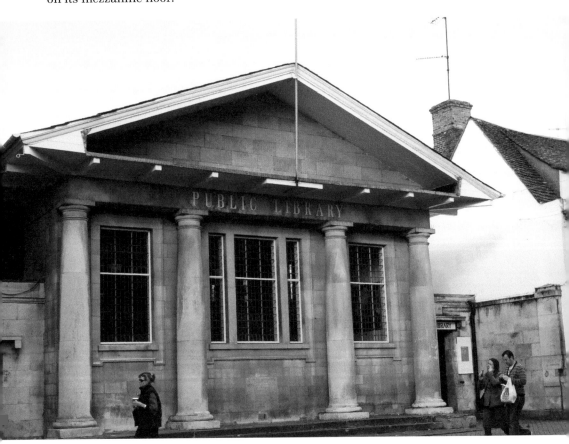

The Portico, originally a market area, now used as a public library.

M

Markets

In addition to the fairs described previously, there were usually four cattle markets in the year. The first three were held on the first Fridays of January, September and October and the fourth on the second Friday of December. These were not, of course, the only markets to be held in the town. Stamford was essentially a market town for the surrounding area. The 'white meat' market stood in what is now Red Lion Square, the 'flesh' market stood outside St Michael's Church until it was moved in 1808. The 'beast market' was in Broad Street and the 'sheep market' was, initially, in Barn Hill. Gathered around the market cross there were sellers of butter and eggs. The vegetable market was in Ironmonger Street. There is also a reference in the Town Hall records to a 'hogg' market but no clear indication to where this was. It is likely however, to have been in Broad Street.

Mint

In 926 King Athelstan granted to the monastery of Medeshamstede (Peterborough) the privilege of a mint at Stamford. This was confirmed by Edgar in 972, and again by the pope in 1145. The mint was situated in St Martin's parish, but its precise whereabouts is unknown.

Motor Manufacturers

Mercifully the Industrial Revolution left Stamford untouched. However, the town was not without its industry. Gibson's iron founders were to be found in Broad street, and the nascent Blackstones in St Peter's Street. Stamford, however, seemed an unlikely place to find a car manufacturer, yet between 1899 and 1925 John Henry Pick was building cars here. Jack Pick, a one-time employee of Blackstones, may well have been the first person in Lincolnshire to build a motor car. Having left his former employer in 1895, he set up a shop at the corner of St Leonard's Street and Brazenose

Lane, where he manufactured a patent hoe that he had invented. A year later in 1896 he went into partnership with A. J. Pledger as a cycle dealers and repairer, at No. 5 Blackfriar's Street. In 1899, he built two dog carts using an engine of French design. The first of these was sold for £85 to a Dr Benson of Market Deeping and the other was sold to the Marquess of Exeter. A third was exhibited at the Stanley Cycle show in 1900. Following this early success, the Pick Motor Company Ltd was formed in March 1900. The directors of the company were the Marquess of Exeter, Sir George Whitcote, W. Bean Esq. and Charles Gray. Pick himself was not a director and became the works manager. Despite disagreements between Pick and the Directors the business did reasonably well, and a new factory was established between Blackfriar's street and St Leonard's Street. The *Stamford Mercury* visited the new factory in 1903 and reported that,

> Some fifty cars are at present in the course of construction, varying from 4 to 24 horsepower. The increasing importance of the manufactory to a town like Stamford, and the extent of the work turned out, may be gauged from the fact that the number of men employed at the commencement had grown to upwards of 100.

However, for reasons that are not entirely clear, Pick moved to No. 11 High Street, St Martin's, in 1904 and set up a new factory advertised as Pick's Motor Works. Initially, they took on any general engineering work they could get, in order to tide them over. By 1906 a new chassis had been built, with a smart two-seater body built by Hayes and Son, of Stamford. This was obviously something of a turning point and it became necessary to find extra production space. So Pick took over the premises vacated by Hayes and Son on the corner of High Street, St Martin's and the Barnack Road (now the Stamford Antiques Centre). Cars built after the move to St Martin's were known as the New Pick, to differentiate them from earlier models. Motor production seems to have carried on until 1915 when the works were turned over to war work. Unfortunately, the works were not taken into government control, which meant that at the end of the war the company was not eligible for subsidies or post-war assistance to replace machinery worn out by munitions production. This may be the reason that Pick did not immediately return to car production. Whatever the reason, he missed out on the post-war demand for motor cars, which led to intense competition between other carmakers. He did approach William Morris with a view to producing engines in Stamford but, quite reasonably, Morris turned him down on the basis that he lacked productive capacity.

A brief venture into producing tractors did little to restore the firm's fortunes. In 1923, Pick refinanced the company with the help of Charles Miles, a local timber merchant. This might have been a turning point in the firm's fortunes; unfortunately, Pick opted to produce a large 22 bhp car with a slow-revving engine at a time when Austin and Morris were producing small cars in response to the £1 per horsepower tax. Not only that, the post-war boom quickly faded and depression set in. Demand for

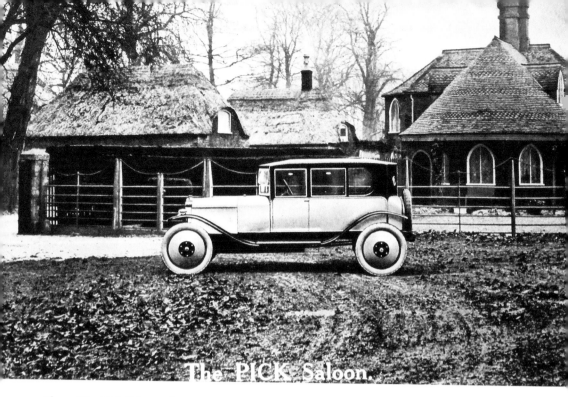

The PICK Saloon.

Above: The Pick Saloon of 1924. The car was 22.5 hp and cost £450.

Right: A 1912 Pick Doctors' coupe.

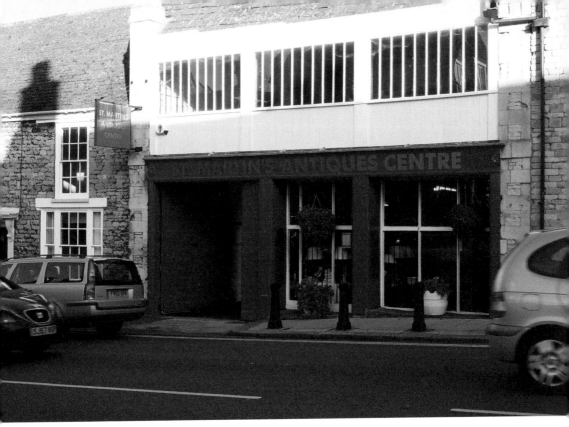

One of the properties in St Martin's once used by Pick to manufacture cars. It is now an antiques centre.

cars fell sharply, particularly for large cars of the type Pick was building. It is doubtful whether Pick sold any of his new models. The firm finally went into voluntary liquidation in January 1925.

No record appears to exist of the total number of cars made by Pick. However, six have survived, quite a large number given that the firm was in production for less than twenty-five years. Two of the surviving cars (a Voiturette of 1901 and a 1912 Doctor's Coupe) are in this country and the others are in New Zealand.

Newspapers

The *Stamford Mercury*, whilst not the oldest newspaper in the country, can claim the distinction that it has been published under the same title longer than any other British newspaper.

During the seventeenth century, the right to publish was strictly controlled under the Licensing Act of 1662. However, for a variety of reasons this Act had lapsed by 1695. Effectively this meant that printing could take place anywhere in the country, not just in London. Although it was not known as such then, this opened the door for the provincial press. The *Stamford Mercury*, began as the *Stamford Post*, and was first published by Thomas Baily and William Thompson from their printing business at No. 52 High street, St Martin's, in 1710. This seems an odd place to have set up in business, but might be explained by the fact that Thompson and Baily were not freemen of Stamford, and may have found it difficult to set up a new business in the town. As with many other newspapers of the time, the *Post* had a political bias and was established in the Tory interest. The newspapers of the time were essentially a distillation of the London newspapers, and Stamford was ideally placed to receive the news from London quite quickly via the coaching services. The title of the *Stamford Post* remained until 1712, when the paper was renamed the *Stamford Mercury*. This was the same year in which the government introduced the Stamp Act which effectively created a tax on all printed material, including newspapers.

In 1714, Thompson and Baily were admitted to freedom provided that they moved into the borough and printed the Corporation's papers. They were also required to employ such poor people as might be recommended to them by the mayor. The paper then moved to No. 1 Broad Street.

Between 1732 and 1771 local chemist Francis Howgrave promoted the newspaper, and his grandson Thomas ran the paper between 1771 and 1783, during which time the paper relocated to Howgrave's house in Maiden Lane. As stated earlier, newspapers in the eighteenth century tended to be a selective distillation of the London news. However, in May 1776 the *Stamford Mercury*, for the first time, began to report local news. In this instance it was reporting the laying of the foundation stone of the new Town Hall. In 1783, the *Mercury* was taken over by Christopher Peat, who enlarged

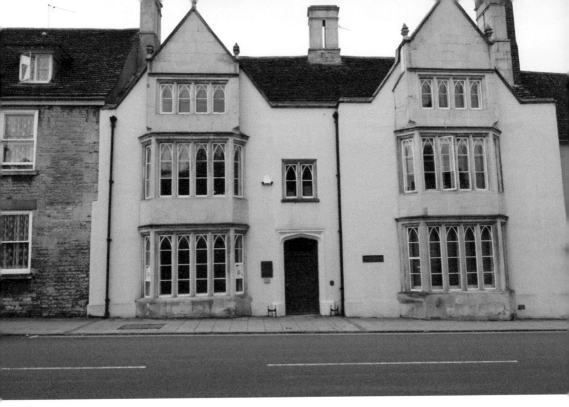

No. 52 High Street, St Martin's, the original home of the *Stamford Mercury*.

the title to the *Lincoln, Rutland and Stamford Mercury*. In 1785, Peat took Richard Newcomb into partnership, and under their joint leadership the *Mercury* flourished. In 1797, Peat retired and Newcomb moved the paper to his own house and shop in High Street, where it was to stay until 1971. Richard Newcomb's son, also Richard, was sent to Bury St Edmunds to learn the newspaper trade and, on his return, entered into partnership with his father. The *Mercury* remained in Newcomb hands until Richard Newcomb II died in 1851. Thereafter, it passed through a number of hands including Westminster Press Provincial Newspapers Ltd, and East Midlands Allied Press. Early in 1938, the modernised High Street premises were reopened. The rear wing of Newcomb's house, a good example of a seventeenth-century, three-storey, gabled building, was dismantled and re-erected as a two-storey waiting room in Sheepmarket.

The *Mercury* continued to be printed in the town until 1970. Since then, only offices remain in Stamford and these have been variously situated at No.33 Broad Street, Sheepmarket, and Cherryholt Road. We are fortunate the Johnston Press, then owners of the *Mercury*, took the decision in 2005 to establish the Stamford Mercury Archive Trust. With the aid of the £305,000 Heritage Lottery Fund grant, the trust has been able to ensure that the *Mercury*'s extensive archive of newspapers are properly conserved, stored and made accessible to researchers.

The *Mercury* was not, of course, the only newspaper to be published in the town; many others have come and gone. The following list is not inclusive, and for a fuller history of both the *Stamford Mercury* and other local papers readers should refer to

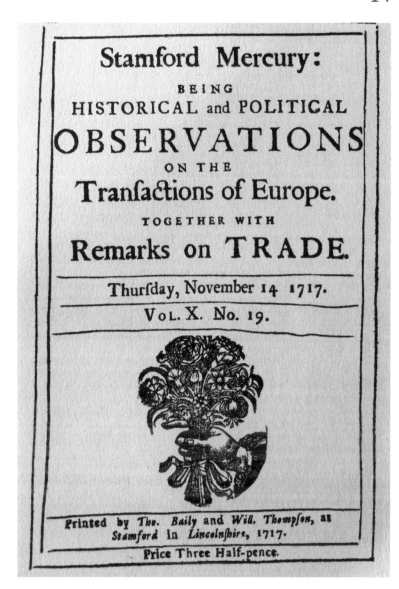

Stamford Mercury:

BEING
HISTORICAL and POLITICAL

OBSERVATIONS

ON THE

Tranfactions of Europe.

TOGETHER WITH

Remarks on TRADE.

Thurfday, November 14 1717.

VOL. X. No. 19.

Printed by *Tho. Baily* and *Will. Thompfon,* at
Stamford in *Lincolnfhire,* 1717.

Price Three Half-pence.

The front page
of the *Stamford
Mercury* for 14
November 1717.

Stamford Mercury, Three Centuries of Newspaper Publishing by David Newton and
Martin Smith. Other local papers include *The Stamford Herald & Loyal Intelligencer*
published by William Harrod between 1793 and 1795, after which it became known
as the *Lincoln, Rutland and Stamford Gazette*. It ceased in around 1798. *Drakard's
Stamford News* appeared between 1809 and 1834. The *Stamford and Boston Gazette*
was published, briefly, by Richard Newcomb between 1809 and 1810. The *Stamford
Champion*, published by Drakard, appeared between 1830 and 1831. Around the same
time was *The Bee*, a paper published in the Tory interest, although this had ceased by
1833. The *Stamford and Rutland Guardian* had a longer run, having been published in
1873. It continued until 1916.

O

Odd Fellows Hall

Odd Fellows Hall was in All Saints Street. It was erected in 1876 on the site of Stamford's first Roman Catholic church, which had been built in 1826. Interestingly, the Globe Tavern was renamed the Albion Tavern in recognition of the Albion Lodge.

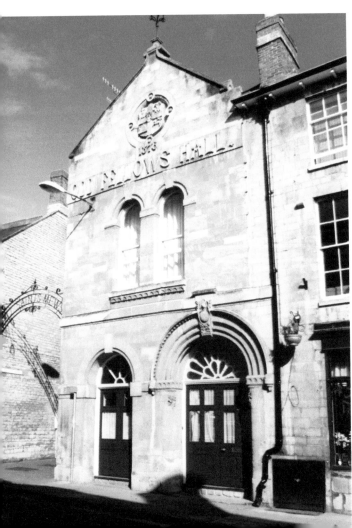

The Oddfellows Hall in All Saints Street.

Owen, Robert

Robert Owen is possibly best remembered for being a philanthropic social reformer, as one of the founders of Utopian Socialism and for the part he played in the foundation of the Co-operative movement. What is not so well known is that he was, for a time, apprenticed in Stamford. Born in Newtown, Montgomeryshire, in 1771, Owen was the sixth of seven children. It is not clear how or why he came to Stamford but, at the age of fourteen, he took up the position of apprentice draper to Mr McGuffog, a draper in St Mary's Street. In the event, he was only with Mr McGuffog for four years since, at the age of eighteen, he left Stamford for Manchester.

Parish Churches

Unusually, for a town of its size, Stamford still has five active parish churches. At the height of its medieval prosperity however, the town could boast some fourteen parishes, each with its own church. These were All Saints in the Market, All Saints by the Bridge, St Andrew's, St Clement's, St George's, Holy Trinity & St Stephen's, St John the Baptist's, St Martin's, St Mary at the Bridge, St Mary Bynwerk, St Michael's in Cornstall, St Michael the Greater, St Paul's, St Peter's and St Thomas'. By 1548 this number had reduced to eleven, with three of the churches having already disappeared. In that year the town council obtained an Act to further reduce the number of churches, which they did by consolidating St John's with St Clement's, All Saints with

A panoramic view of the town showing four of the six churches.

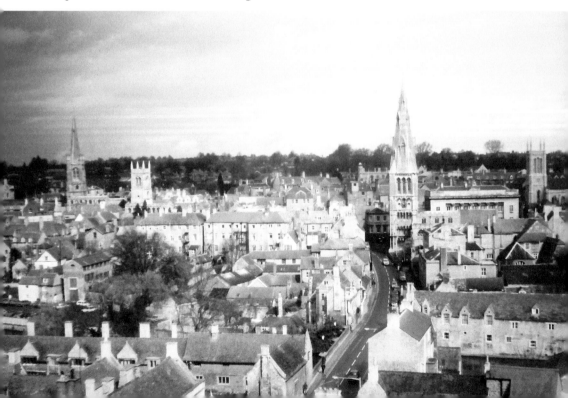

P

St Peter's, St Michael's with St Andrew's and St George's with St Paul's, Holy Trinity & St Stephen's. All Saints by the Bridge (probably at the west end of Water Street) had ceased to be a parish by the middle of the fifteenth century, as had St Mary Bynwerk. In the late seventeenth century the council attempted to amalgamate the churches of St Mary's and St George's, but this came to nothing.

The churches that remain today are St Martin's and St Mary's (in a joint benefice), St George's, All Saints and Christ Church. The shift in population away from the town centre, and the need for a church on the northern side of the town, lead to St Michael's being declared redundant in 1962, and it stood empty for some years before being converted to its present use. As early as 1959 the diocese of Lincoln acknowledged that another church was needed on the north side of the town to cater not only for the Northfields Estate, but also for the growing number of houses between Green Lane and Little Casterton Road. As a result, Christ Church was founded. The original church was situated in Willoughby Road in what was essentially a large wooden hut. It was treated as a daughter church of St Michael's, and then when St Michael's closed in 1962, Christ Church became affiliated to St John's. The original Christ Church building was replaced by a new building in Green Lane. Designed by local architect Vic Chamberlain, the first stage was completed in 1978 and the second stage in 1979. The new church was dedicated by the Bishop of Lincoln. Christ Church became a formal parish in its own right in November 1992. St John's Church was declared redundant in 2003, and is now in the care of the Churches Conservation Trust.

St Martin's Church, rebuilt between 1480 and 1485.

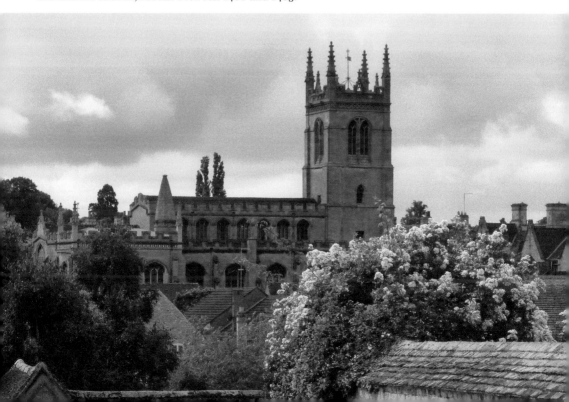

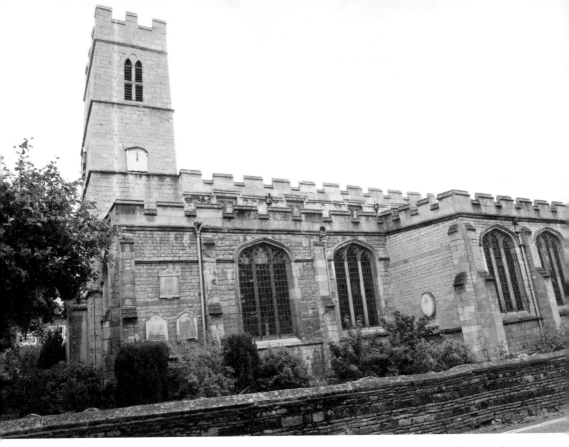

St George's Church. Much of the building is fourteenth century, with the chancel having been rebuilt in the fifteenth century.

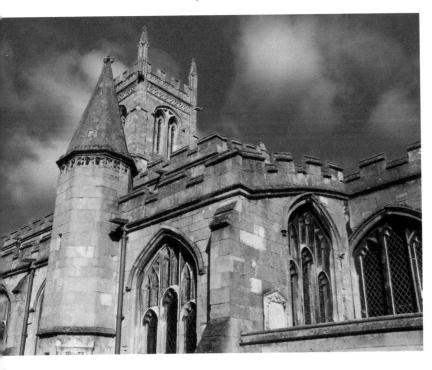

St John's Church. The present building dates from the early fifteenth century.

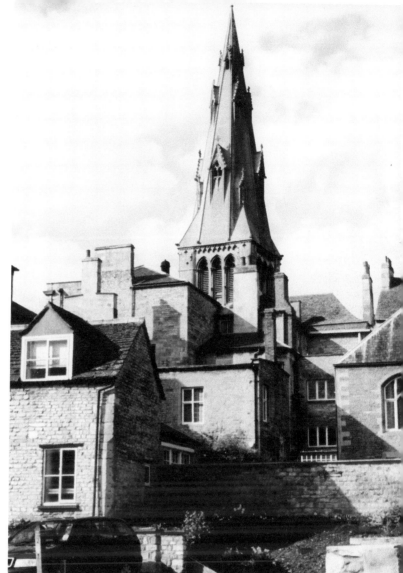

Right: St Mary's Church. The earliest part of the church dates from the late twelfth century, but most of the existing building is thirteenth century, with some rebuilding in the fifteenth century.

Below: Christ Church, Green Lane.

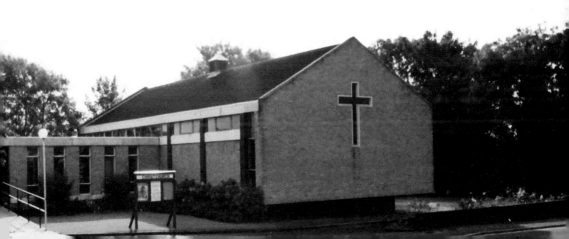

Queen Eleanor's Cross

On the death of Eleanor of Castile in 1290 Edward I had her body conveyed from Harby (Nottinghamshire) to Westminster Abbey. The funeral procession took twelve days to reach London, having travelled via Lincoln, Grantham, Stamford, Geddington, Hardingstone, Stony Stratford, Woburn, Dunstable, St Albans, Waltham, West Cheap and Charing. Between 1291 and 1294, Edward had crosses erected at each of the twelve stopping places, in memory of his Queen. Only three of the original crosses remain, at Geddington, Hardingstone and Waltham Cross.

The site of the Stamford Eleanor Cross has never been satisfactorily resolved. It is known that the cross stood for at least 350 years, confirmed by two seventeenth-century reports. The first of these was by Richard Symonds, a captain in the Royalist army. In his diary for 22 August 1645, he records having visited Stamford briefly on his way from Newark to Huntingdon:

> In the hill before ye come into the town stands a lofty large cross, built by Edward
> I in memory of Eleanor his queen, whose corps rested there coming from the north'.
> A year later, in 1646, Richard Butcher the Town Clerk in his survey of Stamford wrote,
> 'Near unto York highway and about twelve score paces from the town gate which is
> called Clement Gate, stands an ancient crosse of freestone of a very curious fabrick,
> having many ancient scutcheons of arms insculped in stone about it as the arms of
> Castile and Leon quartered being the paternal coat of the King of Spain and divers
> other hatchments belonging to that crown which envious time hath so defaced that
> only the ruins appear to my eyes and therefore not be described by my pen.

One earlier reference to the cross appears in the *Hall Book* for 30 November 1621 and records that 'the Hall also agreed that the fate of the Kings Crosse shall be forthwith amended by sufficient workmen'. Francis Peck's *Antiquarian Annals of Stanford* tell us that the cross was destroyed between 1646 and 1660, probably by Parliamentarian 'fanatics'.

What has fuelled the Stamford debate about the position of the cross is that at various times bits of masonry said to have been parts of the cross have been found

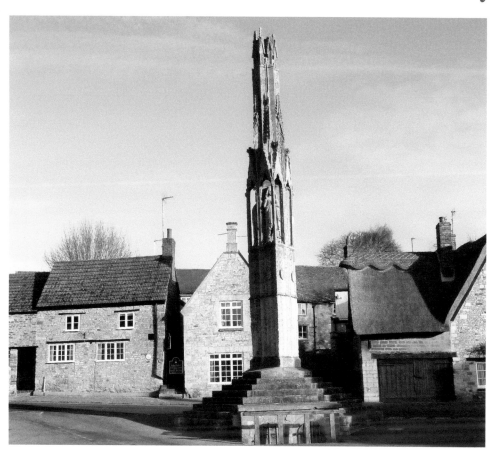

Above: The Eleanor Cross at Geddington. Stylistically, this is said to be similar to the Stamford Cross.

Right: Detail of the Geddington Eleanor Cross, which shows remarkably little wear given its age.

at a number of points between Clock House and the Foxdale area of Casterton Road. For example, on 16 January 1745 the noted antiquary William Stukeley wrote that 'Our surveyor of the turnpike road opened up a tumulus half a mile north of Stamford on the brow of a hill by the roadside and there discovered the foundations of the Queen's Cross.' The description given by Stukeley of what was found does suggest that it was the base of the cross. However, being half a mile north of the town, the location does not sit well with Richard Butcher's twelve score paces from Clement Gate. This debate will probably go on for some time, but what confuses the issue is that Butcher was reporting what he could see, and his twelve score paces measured from Scotgate crossroads will take the walker to Clock House and the junction of Casterton and Empingham roads. This would seem to have been the logical place to have erected the cross, rather than further up Casterton Road which, at that time, would have been open country. More recent evidence however, suggests that he was wrong. In 1993 a fragment of Purbeck marble with a rose carved on one of its surfaces was found in the garden of Stukeley House, Barn Hill. This was William Stukeley's home in the 1740s. The appearance of this fragment accorded with the description of the upper shaft of the Stamford Eleanor Cross, which Stukeley claimed to have found in 1745 on Anemone Hill, which is on the upper part of Casterton Road. Further research confirmed the fragment to be part of Stukeley's find. So we can conclude that Stukeley had almost certainly discovered the site of the Eleanor Cross, in what we now refer to as the Foxdale area of Casterton Road. A modern interpretation of the Eleanor Cross by Wolfgang Buttress stands in Sheepmarket.

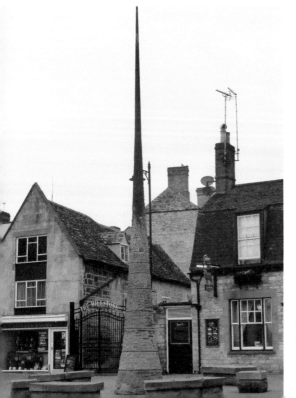

The modern rendition of the Eleanor Cross in Sheepmarket.

R

Railways

Few towns as small as Stamford have two railway stations, and therein lies another peculiarity of the town's history. Much has been written about whether the Great Northern Railway was intended to be routed through Stamford or not. There is a school of thought that suggests that it was always intended to bring the GN line through Stamford, but that this did not happen because the 2nd Marquess of Exeter had withdrawn his support for the line. This was not the full story however. At the time many local people felt that if the GNR could be routed through the town it would attract industry, which would bolster the town's economy following the decline of coaching. There was a public meeting held at Standwell's Hotel (later the Stamford Hotel) on 22 May 1844 to discuss the issue and there was considerable support for bringing the line through Stamford. Decisions of this magnitude, however, are rarely made at local level and the decision was taken in August 1844 to route the line through Peterborough. Two years later, in 1846, Parliament sanctioned the building of the Great Northern Railway between London and York. This was a significant undertaking, which also made provision for a loop line via Spalding and Lincoln. At that time, there were frequent disagreements between the aristocracy and the railway companies over routes, particularly where the proposed route was likely to interfere with hunting. The 5th Earl Fitzwilliam had his surveyor draw up a plan to revise the route of the GNR where it passed across Milton Park for just this reason. Numerous reasons have been cited for why the 2nd Marquess of Exeter withdrew his support, from not wishing to see the railway from Burghley House to being dissatisfied with the money the railway company were prepared to pay to cross his land. Logic however, suggests that a line through Stamford was never part of the railway company's plan, since a deviation to Stamford would have added significantly to the cost.

A year earlier, in 1845, work had begun on the Syston–Peterborough Railway, which was certainly intended to pass through Stamford. The section between Peterborough and Stamford was completed and opened on 2 October 1846. However, at this point there was still no line westward from Stamford, due to engineering difficulties and problems between the railway company and Lord Harborough at Stapleford Hall. A temporary station had been built at the end of Water Street

Above: Stamford Midland station, built in 1848 to a design by Sancton Wood.

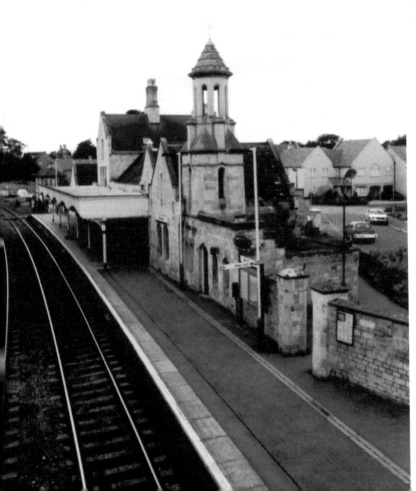

Left: Stamford Midland station.

pending the completion of the tunnel under St Martin's, and it was from here that the first trains to Peterborough left. It was June 1848 before running was possible over the whole line and the imposing new Stamford Town station, designed by Sancton Wood, could be brought into use (now featured in Simon Jenkins' book *Britain's 100 Best Railway Stations*).

While the opening of the SPR put Stamford on the railway map, the story does not end there. Stamfordians travelling to London had first to travel by horse omnibus to Essendine or Tallington in order to catch their train. Unfortunately, GNR trains were not booked to stop at Tallington and it became necessary to remind the GNR of the agreement made with Lord Lindsey that they should do so. However, this did not solve the problem and eventually an appeal was made to the Vice-Chancellor of England who, in 1853, issued an order enforcing the agreement made with Lord Lindsey.

Tallington became the preferred station since the journey by horse omnibus was over relatively flat terrain. However, a second line had been proposed by the Marquess of Exeter from Stamford to connect with the GNR at Essendine. This line received royal assent in August 1853, despite there being objections to it from the Midland Railway during the bill's progress through Parliament. Work began on the line, initially from

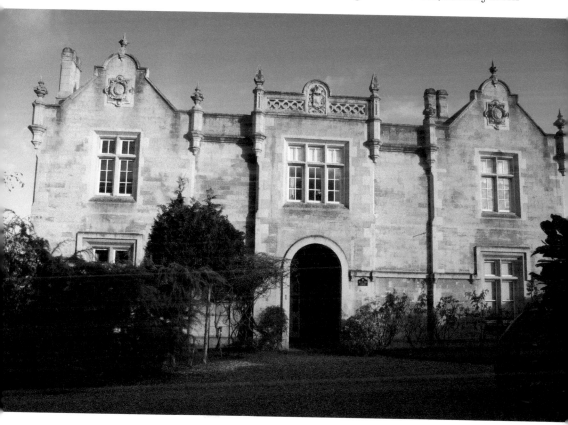

Stamford Great Northern station as it is today.

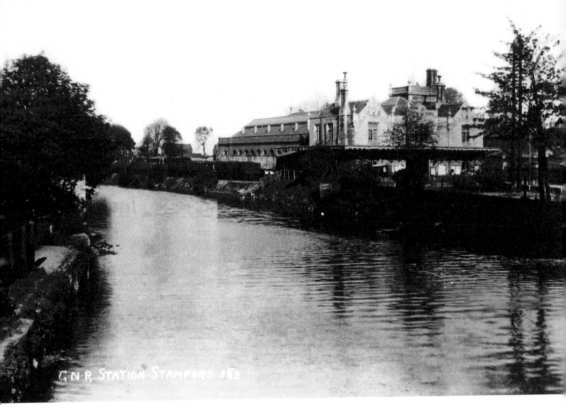

Stamford Great Northern station in the late nineteenth century.

the Essendine end, in 1854 and it was completed by October 1856 and opened on 1 November 1856. The total cost was £46,000. The Directors of the S & E Railway had clearly not intended to build another station since, in 1855, they had approached the Midland Railway concerning running powers into the Midland station. Given the Midland Railway's objection to the S & E Railway in the first instance, they were clearly not receptive to this idea, so the S & E Directors pushed ahead with plans for their own station on the site of the original Midland station at the end of Water Street, designed by William Hurst.

Hurst produced a handsome design in the style of an Elizabethan mansion; an edifice that was to be the subject of many model railway projects in future years. Presumably in recognition of its main patron, the station displayed the Exeter coat of arms on its frontage. The line was initially run by the GNR, but its contract was not renewed and, in 1865, the S & E company took over the running of the line themselves.

The Stamford to Essendine line closed to passengers on 15 June 1959.

S

Schools

The history of schools in Stamford deserves a book in its own right. However, space precludes anything other than a bare outline of how educational provision developed in the town. The Victoria County History of Lincolnshire makes reference to a grammar school in Stamford in 1309. Little is known about the school at that date, but it clearly continued as, in 1389, the Dean and Chapter of Lincoln granted John Langham, schoolmaster of the town of Stamford (magister scholarum ville de Stanford), leave of absence to go on a pilgrimage to Rome. It is probable that, at that time, the school was maintained by the many gilds in the town; in fact, it is thought that teaching was originally carried out in the chapel of the Corpus Christi Gild. The present Stamford School dates from 1532 when it was founded under the will of William Radcliffe.

St Martin's school, which stands at the junction of High Street, St Martin's and Kettering Road. It is now the music department of Stamford High school.

The year 1604 saw two schools established in the town: All Saints and St Martin's. All Saints school (originally known as Wells Petty school) was founded under the will of Edward Wells, a shoemaker who lived in St Peter's parish, and who died in the plague outbreak of that year. When the school opened, the malthouse at the rear of Well's house was used as the classroom. Two classrooms were added in Austin Street in 1866. St Martin's school was founded by Dorothy Cecil, wife of Thomas, 1st Earl of Exeter. The school, which closed in December 1962, occupied the building on the corner of High Street, St Martin's, and Kettering Road, which is now the High School music department.

The Stamford Bluecoat school was founded as a spinning school by the Corporation in 1704. The school was set up in a house on St Paul's Street, on the site of the former Brazenose College. The children were taught reading, writing and religious

The former All Saints school in Austin Street, now converted to residential use.

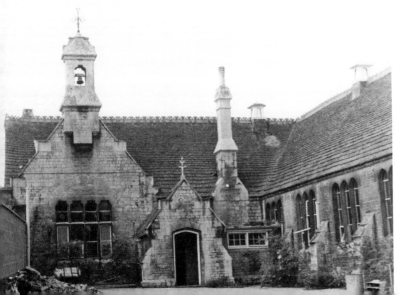

The former home of the Bluecoat school on St Peter's Hill, now a Masonic Lodge.

instruction as well as how to spin. The school was under the auspices of the SPCK who, in 1704, reported that '100 children were taught to read and the Catechism. They are all clothed and set to work, and about 50 of them can earn 3d a day',
The school moved to St Peter's hill in 1838 at which time 150 boys were attending, 60 of whom were clothed. The school moved to its present Green Lane site *c.* 1968.

The Girls National school, which later became St George's school, opened in Wharf Road in 1815. The school was established out of the surplus funds of a lying-in charity.

St John's school was established in 1861, one of many church schools established nationally at that time. An extension to the school was opened in 1872. Until 1892 it was a combined infant, junior and senior school, but in that year it became an infants' school. In 1965, St John's combined with All Saints school, which had already been joined with St Martin's, to form the St Gilbert of Sempringham school.

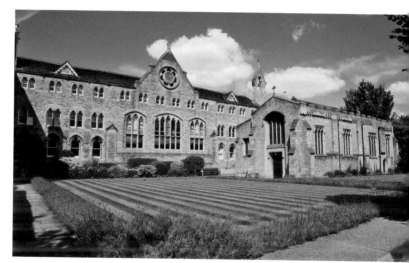

Right: Stamford school and chapel, St Paul's Street. The chapel is the former St Paul's Church.

Below: St Michael's school, Recreation Ground Road. This photograph was taken just prior to its demolition. The site is now occupied by the Burghley Court housing development.

St Michael's school appears to have opened in around 1855. An HMI report for 1860 complains that the school, for the last five years, has been held in a 'low, dirty, dark, non-ventilated room belonging to the Dolphin public house (Broad St). Between the schoolroom and the "public" there is a direct communication of which one of the masters appears, not infrequently, to have availed himself'. On 4 September 1860, new school buildings were opened at the bottom of Recreation Ground Road.

Stamford High School for Girls was originally known as Browne's Girls school and had opened in imposing premises in St Martin's in 1876.

The Fane school was established in Green Lane in 1927. As part of the secondary school reorganisation in the 1980s, it was amalgamated with the Exeter school to form the new Queen Eleanor school. In 2011 the school became an academy and, in 2014, became part of the Cambridge Meridian Academies Trust and the name was changed to Stamford Welland Academy.

The Exeter C of E Secondary school in Empingham Road had been opened by Princess Margaret in 1961. Unfortunately, in what seems to have been a shortsighted decision, the school closed in 1987 on its amalgamation with the Fane school. The last new school to open in the town was the Malcolm Sergeant school in Empingham Road, which opened in 1973.

Priory College, an independent school, was based in Wothorpe with the preparatory department being in Wharf Road. Both parts of the school closed in 1995.

St Leonard's Priory

St Leonard's Priory was a Benedictine foundation and a cell of the priory established at Durham Cathedral. A fifteenth-century document stated that St Leonard's was built on the site of an earlier monastery which had been founded by St Wilfrid in 658, and destroyed during the Danish invasion. However, more recent research suggests

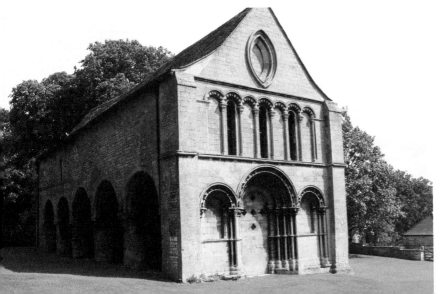

St Leonard's Priory is a Benedictine priory of uncertain date. The buildings that remain date from the twelfth century.

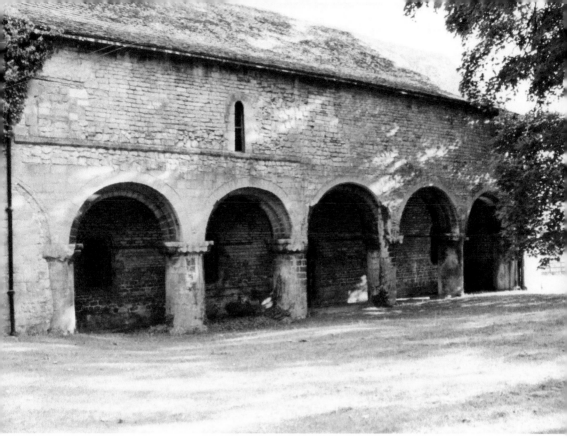

St Leonard's Priory, north arcade.

that this was not the case. St Leonard's was jointly founded by William the Conqueror and the Bishop of Durham *c*. 1082. The priory remained a cell of Durham until its dissolution in 1538. Excavations carried out between 1968 and 1972 show this to have been quite a large site, with extensive buildings. The building that remains today is part of the twelfth-century north arcade and the west front.

St Martin's Parish, Stamford Baron

It is a peculiar anomaly of the town's history that for much of its history St Martin's parish lay in the diocese of Peterborough and the county of Northampton. The reason for this was that the parish was in the Soke and Liberty of Peterborough. There are early references to the parish as Stamford beyond the Bridge, but the term St Martin's seems to have gained currency quite early on. John Drakard suggests that 1455 is the first recorded use of the term Stamford Baron. He further conjectures that, in all probability, the word 'Baron' was added as it was part of the lands which the Abbot of Peterborough held *per baroniam* and to distinguish it from Stamford, which was always called the king's borough. We can be fairly certain about the point at which the parish became settled since the Anglo-Saxon Chronicle tells us that 'In this year (922), between Rogation days and Midsummer, king Edward marched with his levies to Stamford, and

had a fortress built on the south bank of the river; all the people who owed allegiance to the more northerly fortress submitted to him and sought him for their lord.'

From this point on, the parish seems to have developed almost as a village outside of a town. It had its own officials and its own courts. Clearly there was interchange between the parish and the town, but the relationship was a complex one. It was not until the 1835 Municipal Corporations Act that the parish officially became part of the Borough of Stamford.

Stamford Scientific and Literary Institute

This imposing building stands on St Peter's Hill opposite the site of St Peter's Church. Built in 1842, on the site of the former Castle Inn, it was designed by local architect Bryan Browning in a Greco-Egyptian style. The building contained a large concert and lecture hall, a library and a museum gallery, newspaper and committee rooms and a laboratory. On the roof there was an octagonal observatory, with a camera obscura; this was removed in 1910.

The institution began its life in premises in Broad Street in 1838. Lectures on the arts and the scientific issues of the day were a regular feature of the institute. It closed in 1910, and the contents of the museum were sold off.

Below left: The former Stamford Scientific and Literary Institute on St Peter's Hill.

Below right: A nineteenth-century picture of the Scientific and Literary institute. This shows the camera obscura still in place.

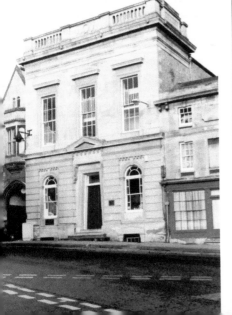

T

Terracotta Manufacture

During the nineteenth century, there were at least three terracotta manufacturers in the town. By far the largest of these was that of John Marriott Blashfield, a terracotta manufacturer of international repute who established a works on Wharf Road. His Wharf Road works were opened in March 1859, although Blashfield had been manufacturing the product since at least 1842, probably at his works in Poplar.

The first Stamford kiln was fired in the presence of the Marchioness of Exeter and her family. Not long after that, a bust of Queen Victoria, fired in this kiln and made of Wakerley

The former Scotgate Inn, a good example of terracotta work produced by Blashfield's terracotta works in Wharf Road.

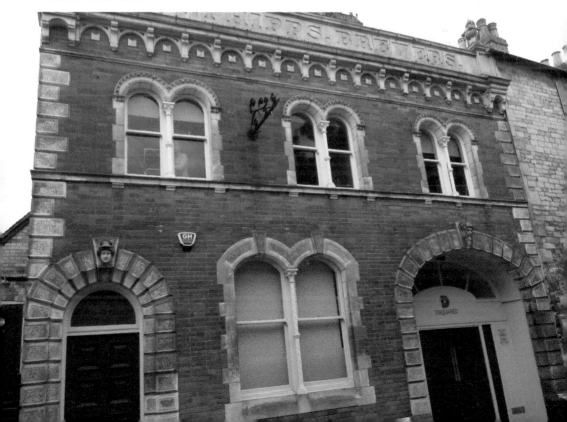

The upper part of the frontage of No. 30 High Street. This also has ornamentation by Blashfield.

clay, was presented to Her Majesty by Prince Albert. In the preface to his 1875 catalogue, Blashfield commented on the way in which stone decays, and he saw the answer to this as 'good plain moulded brickwork, accompanied by terracotta enrichments'.

Examples of Blashfield's work can be seen on No. 30 High Street and the former Scotgate Inn. By 1863 all of Blashfield's production had been moved to Stamford, and he employed a considerable number of workers, many of them Italians. Changes in the market, however, forced the firm into liquidation in 1875. Towards the end of 1860 John Lumby established a kiln in St Martin's, and in 1863 Charles Joseph Whiten was operating a terracotta works in London Road.

Theatre

There is evidence to suggest that there was professional drama in the town before the building of the present theatre in St Mary's Street. For example, the *Mercury* of 18 September 1718 announced that 'Mr Kerrigan's company of comedians will be at the Guild Hall in Stamford, during the time of the horse races, where will be acted comedies etc with several new and diverting entertainments.' Although this performance was given in the Guild Hall, there appears to have been an earlier theatre building. The *Mercury*, for example, refers to a theatre before 1768 and Burton, in describing the present theatre, talks of it having replaced an earlier theatre. The present theatre was opened in March 1768 and the *Mercury* reported that 'On Monday last the New Theatre was opened here by Mr Whitley's Company of Comedians, with the comic opera of Love in a Village, which was performed much to the pleasure and satisfaction of a very numerous and polite audience.' Stamford's theatre is thought to

be one of the earliest provincial theatres, and for over 100 years provided a wide variety of entertainment for local theatregoers. However, in 1871 it closed and for the next 100 years had a number of uses including becoming a billiard club. For some years, the future of the building looked in doubt but, in 1977, it was completely refurbished and, in March 1978, was reopened as a theatre by the Duchess of Gloucester.

Town Bridge

The Domesday Book records that Stamford had six wards, five in Lincolnshire 'and the sixth in Northamptonshire, which is beyond the bridge'. So we know that Stamford had a bridge in 1086. This bridge was, however, replaced in the twelfth century. The medieval bridge was built in Barnack stone and was 150 feet long, 14 feet wide at the south end narrowing to 11 feet wide at the north end. Five arches carried it across the river; triangular recesses in the parapet provided refuge for foot passengers from horse-drawn vehicles. Today, a similar example can be seen across the River Nene at Wansford. By the end of the Middles Ages, this bridge had a gate at the north end, the upper part of which was the Town Hall. The gate was demolished in 1778 when the Wansford Road Turnpike Trustees improved the road and provided a new Town Hall on St Mary's Hill. The present town bridge was designed by Edward and Henry

The modern town bridge. A bridge is mentioned in the Domesday Book, and a five-arch stone bridge was built in the twelfth century. The present bridge dates from 1849.

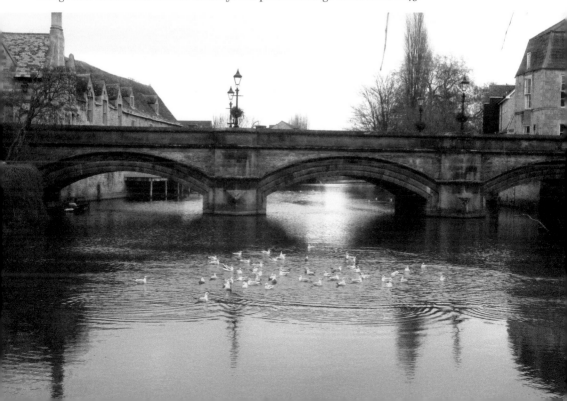

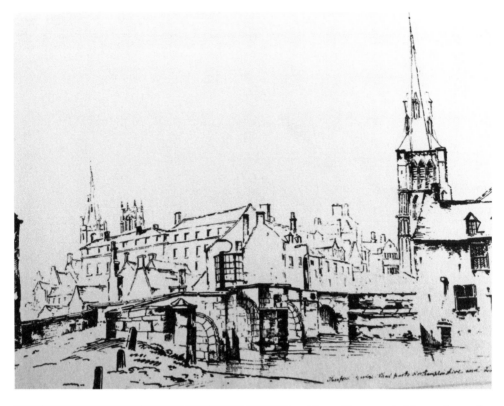

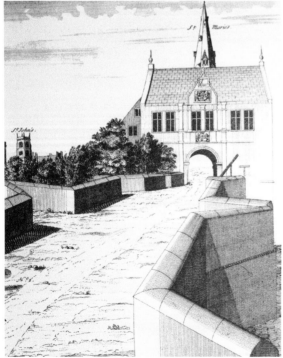

Above: The town bridge as drawn by Nattes in 1804.

Left: The town bridge as illustrated in Peck's *Antiquarian Annals of Stamford*.

TOLLS TO BE TAKEN AT THIS BRIDGE	L.	s.	d.
For every laden waggon (Passing or Repassing) the sum of	—	—	4
For every laden cart Do . .	—	—	2
For every Horse laden or led . . . Do . .	—	—	0½
For every Stone Horse Do . .	—	—	1
For every score of Beast Do . .	—	—	4
All Beasts under five Do. each	—	—	0½
For every score of cows & calves . . Do . .	—	—	8
For every score of Hogs Do .	—	—	8
For every score of Sheep Do . .	—	—	2
For every pair of Millstones . . . Do . .	—	—	6

A board displaying the bridge tolls. This was placed at the southern end of the bridge.

Browning and was the last major building contract carried out by local builder Robert Woolston. Unfortunately, for Woolston at least, it proved to be a financial disaster. The Act obtained in 1846 for the Syston and Peterborough Railway had described the old medieval bridge as being 'dangerously narrow' and required the railway company to contribute the sum of £5,000 towards widening the bridge. Lord Exeter had the right of tolls, but townspeople were exempt from payment.

During the building of the new bridge, traffic was diverted along Wothorpe Road, across the George Bridge, the meadows and the Lammas Bridge into Sheepmarket. Work on removing the medieval bridge began in 1847 and the new bridge was completed, not without many problems, in 1849. Robert Woolston experienced problems in removing the old bridge and had to battle against continual flooding in the coffer dams around the new piers. Due to the problems he was experiencing, Woolston had made a loss of £2,000 by March 1848, and he obtained a second contract with a projected completion date of January 1849. However, the problems persisted and he relinquished his contract in April 1848 and declared himself bankrupt. Edward Browning, the architect, then took control of the building work, which was completed in March 1849. The three segmental arches, built in Bramley Falls stone, are carried on substantial piers. At the north end a Tudor-style toll house was built for the keeper of the toll.

The final cost of the bridge was £8,000, of which £5,000 had been contributed by the Midland Railway and the balance by Lord Exeter. The right of toll was dropped after Lord Exeter had recovered his contribution to the building.

University

Stamford has always seen itself as being a centre for education. This perception may hark back to the monastic schools of the Middle Ages or possibly the succession of Oxford students to Stamford in the twelfth century. Some years ago, chronologies of the town referred to a university being established here by the British Prince Bladud in 863 BC. There is, of course, no credible evidence for this and we can probably agree with John Drakard that it was 'only of imaginary existence'. However, in November 1333, during the disputes between northern and southern scholars at Oxford, a number of students and their masters from Brazenose Hall and Merton College migrated to Stamford and attempted to establish a collegiate hall. Evidence suggests that, initially, the scholars were able to continue their studies without interference. However, this move had alarmed both Oxford and Cambridge universities, who were concerned about the possibility of a third university being established. The two universities petitioned Edward III, Queen Philippa and the Bishop of Lincoln to outlaw the nascent Stamford University and compel the students to return to Oxford. Early in 1334, the scholars, realising that they were unlikely to be allowed to stay in Stamford without royal assent, petitioned the King to allow them to continue their studies under the protection of John, Earl Warenne. The King, however, sided with the Oxford authorities, and commanded the High Sheriff of Lincoln to go to Stamford and forbid everyone to hold studies or exercise scholastic acts anywhere within his jurisdiction under threat of confiscation of all their possessions. Initially, some of the scholars complied and returned to Oxford; others remained in Stamford.

This first attempt to expel all of the masters and students from Stamford having failed, the king repeated his order in November 1334, and directed the sheriff to return to Stamford and enforce the edict, with the added caveat that he was to seize their books and goods and report their names. This second attempt also failed and the king commanded Baron William Trussel to accompany the sheriff to Stamford and order the scholars and masters back to Oxford. This time, they did leave but later returned for several months, encouraged by the people of Stamford. Eventually, however, they had little option but to return to Oxford. Thereafter, Stamford's educational development followed the pattern of many other market towns. Stamford school was

founded in 1532 under the will of William Radcliffe, and Well's Petty school (later All Saints school) was established under the will of Edward Wells in 1604 with the Bluecoat school being founded a hundred years later in 1704. In the course of time, all of the parishes opened their own schools. Possibly because of its situation on the Great North Road, Stamford attracted a significant number of private schools during the eighteenth and early nineteenth centuries. In 1842, there were no fewer than twenty-two private schools and academies in the town, many of them in the St Paul's Street and Barn Hill areas.

For a short time in the 1960s, there was a very real possibility of Stamford becoming a university town in its own right. The University Grants Committee had advised the creation of four additional universities following the creation of the universities of Sussex, East Anglia and York. With the full support of Kesteven County Council, Stamford moved forward with its application, believing that a university would give the town added status, as well as bringing economic benefits. However, despite mounting a strong bid, the four additional universities were established at Bournemouth, Plymouth, Cheltenham (with Gloucester) and Lancaster.

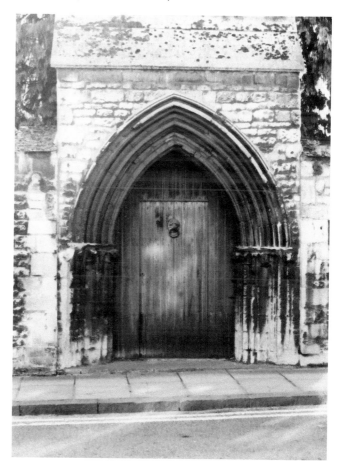

Brasenose Gate, St Paul's Street. This stands on the supposed site of Brazenose Hall where Oxford masters and students set up their rival university in 1333. However, there appears to be no medieval evidence to confirm that this was the site.

Visitors

During its long history, Stamford has had many thousands of visitors, including royalty. Few however, have left us their impressions of the town. This changed in the late seventeenth and early eighteenth centuries when travel became easier, and people started to travel for pleasure rather than for business. Possibly the earliest such traveller to comment on Stamford was Celia Fiennes. She undertook a number of tours around the country in the late seventeenth century, and on her 1697 tour from London to Yorkshire she stayed in Stamford. She described Stamford as 'fine a built town all of stone as may be seen; its on the side of a hill which appears very fine in the approach. Severall very good churches with high spires and towers very ornamental, its not large, but much ffiner than Cambridge, and in its view has several good houses'. It should be remembered that, at that time, Stamford was emerging from a long period of depression, but had clearly pulled through sufficiently to impress someone who had already travelled much of England.

Daniel Defoe, in his Tour published between 1724 and 1726, described Stamford as possessing 'evident marks of its having been a very great place in former days'. He also observed that the town was 'at this time a very fair, well built, considerable and wealthy town, consisting of six parishes, including that of St Martin Stamford-Baron:

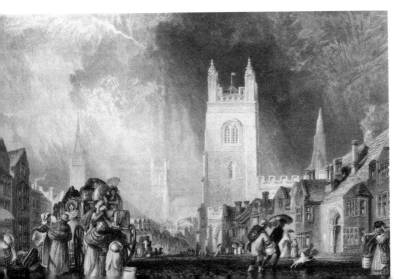

Image of Stamford by William Miller, 1796–1882, British, after J. M. W. Turner. (Yale Center for British Art, Paul Mellon Collection)

that is to say, in that part of the town which stands over the river, which tho' it is not part of Stamford, critically speaking, yet 'tis all called Stamford and is rated with it in the taxes and the like'. Defoe also noted that 'There is a fine stone bridge over the river Welland of five arches. The Town Hall is in the upper part of the gate upon or at the end of the bridge, which is a very handsome building.' Defoe, interestingly, sees fit to comment on the governance of the town and wrote 'The government of the town is not, it seems, as most towns of such note are, by a Mayor and Alderman, but by an Alderman, who is chief magistrate, and twelve comburgeses, and twenty four capital burgesses, which, abating their worships titles, is, to me, much the same thing as a mayor, aldermen, and common council.' This is an interesting observation, and far be it for me to suggest that Defoe had misunderstood the situation. But for much of the seventeenth century the council had been petitioning Parliament to become a mayoral town, as was the case with Grantham, and this had finally been granted in the late seventeenth century, long before Defoe visited the town.

It is interesting that both Fiennes and Defoe wrote about the town in glowing terms, yet these comments predate much of the eighteenth-century developments on St Mary's Hill and along St Mary's Street. Artist J. M. W. Turner also visited Stamford around 1795 and took the opportunity to produce at least one sketch of the town. His 1828 painting of High Street, St Martin's (now in the Usher Gallery, Lincoln), was produced from a sketch he made in 1795.

Later visitors were equally impressed. Sir Walter Scott is said to have doffed his hat to the view up to St Mary's Church, and proclaimed it was the 'finest sight on the road between London and Edinburgh'. Sir John Betjeman thought that Stamford was 'England's best town'. Pevsner described Stamford as the English country town 'par excellence'.

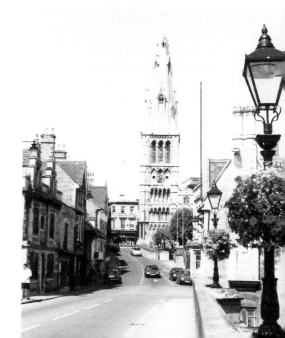

The view of St Mary's Hill and Church said to have 'inspired' Sir Walter Scott.

Wake Stone

The Wake Stone caused something of a sensation when it was brought to light during the demolition of the Albert Hall (now Tescos) site in 1966. The inscribed stone commemorates Blanche, Lady Wake, widow of Thomas, the 2nd Baron Wake. She was the daughter of Henry Plantagenet, 3rd Earl of Lancaster. Lady Wake died in 1379 and was buried in the church of the Greyfriars in Stamford. Thomas, Lord Wake, was Lord of the Manor of Bourne and Constable of the Tower of London. Blanche lived on for thirty years after his death in 1349 and directed in her will that she should be buried in the church of the Greyfriars. The stone, which was possibly part of a larger 'Wake' monument, had been incorporated as a hearthstone in one of the fireplaces in the Albert Hall. Fortunately, it had been placed with the inscribed face downwards, although, either earlier or during the demolition, the stone had cracked into four pieces. They were later bonded together by the late A. S. Ireson, at his studio in Tinwell. The inscription on the stone reads 'All who enter this house pray for Blanche, wife to

The Wake Stone, now housed in St George's Church.

Lord Wake, daughter to Henry, Earl of Lancaster, on whom God have true mercy'. The stone is now permanently secured in St George's Church, Stamford.

Walls

Almost nothing now remains of the medieval town walls. However, their line can largely be traced in the present road pattern. The walls enclosed an area of around 75 acres, and the line of the walls follow the modern West Street, North Street, Elm Street, Brazenose Lane and Wharf Road. There were several gates in the walls, but all of these have now been demolished. Richard Butcher, writing in the seventeenth century, referred to there also being five towers, which he named as Beesfort, Holme, Carpe, White Tower and North Bulwarke. Only one of these now remains, which is now referred to as the Bastion, and stands in West Street, near the former St Peter's gate.

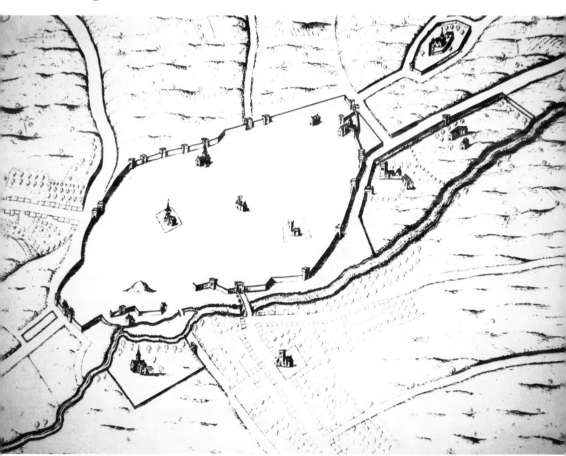

An early seventeenth-century map showing the town walls as they were before the Civil War.

The Bastion. This was one of five similar towers along the town walls.

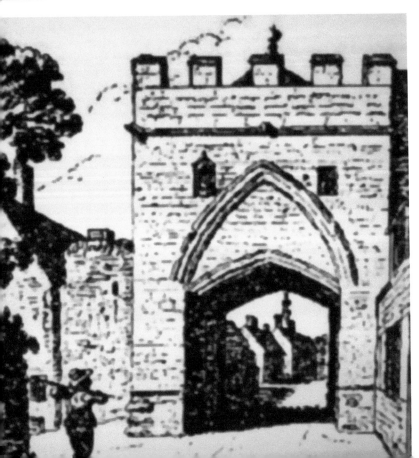

A drawing showing St George's gate. It is thought that the gates in St Peter's Street and Scotgate were similar to this.

Welland (River)

The River Welland is some 65 miles long and rises in the Hothorpe Hills at Sibbertoft. It meanders through Market Harborough, Stamford and Spalding and empties into the Wash near Fosdyke. At the height of Stamford's medieval prosperity, the river was well used for the import and export of goods. However, during the period of the town's decline, the river became silted up due to lack of use. The Borough Council were well aware of the importance of the river in re-establishing trade in the town, and petitioned Parliament for an Act to make it navigable again. Thus, the Welland became the one of the first rivers in England to receive an Act of Parliament (1571) to make it navigable to the sea. The application for the Act was made by the Town Council stating that 'Their town, which had formerly been inhabited by many opulent merchants, whose wealth had been advanced by the navigation of the river Welland, and its connections with Boston, Lynn and other ports, was then gone to great ruin and decay, from the prejudice done to the navigation by the erection of mills between Deeping and Stamford, and the consequent diversion of the stream of the river from its ancient course'.

However, despite the council obtaining the Act, it does not appear that any work was actually done on the river at that time. Following numerous false starts in the late sixteenth and early seventeenth century, including a royal charter signed by James I

The River Welland from the east.

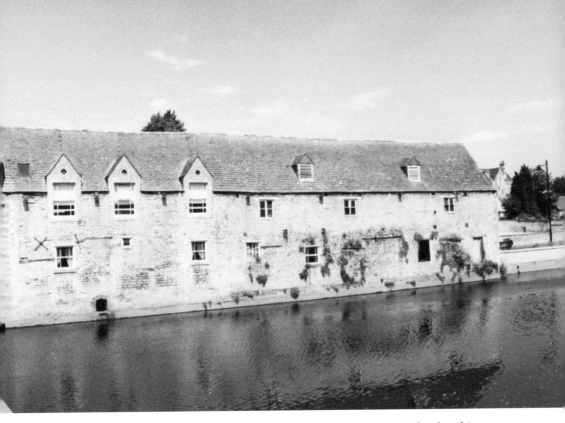

Seventeenth-century warehouses on the north bank of the river, a reminder that this was once a busy inland waterway.

in 1621 granting the Corporation leave to make a new cut, it was not until after the Civil War that any progress was made. In 1664, Daniel Wigmore, a wealthy woollen draper and three times mayor of Stamford, undertook to make the river navigable once again at a cost of £5,000. Wigmore was to receive a lease on the tolls for a period of eighty years.

A new cut was constructed with ten locks between Stamford and Market Deeping. A further two locks were constructed on the river section below Market Deeping. The canalised section became known as the Stamford Canal, and at the time of its construction was the longest canal with locks in the country. Proposals were made in 1786 to connect Stamford with the Oakham Canal, and this became a significant issue in the 1809 election. However, a rival proposal for a canal from Market Harborough to Stamford caused a clash of interests. Neither of these proposals are unusual given that they were made at the height of the 'canal mania'. However, in the event, neither proposal was put into practice.

We can be reasonably certain that improvements in the river and the development of the malting trade in the town go hand in hand. At that time, most of the corn was conveyed by water, and all malting towns had their river connections. In the 1830s there were thirteen maltsters recorded in the town. However, change in the form of the railways was soon to overtake river traffic and navigation on the upper Welland, including the Stamford Canal, had ceased by 1863.

X

X Marks the Spot

Vigilant walkers in Stamford may have noticed an X inscribed into the wall of certain buildings. These are parish boundary marks, and were used to delineate where one parish finished and another started. They only relate to the parishes north of the river, as the area south of the river was one parish. Reference to early maps, particularly James Knipe's map of 1833, will show that the various parish boundaries were irregular in shape. For example, St Michael's, Holy Trinity and St Stephen's (later to become one parish) were separated by a wedge of St George's parish which completely divided them. Similarly, St John's parish was in two parts, being separated by All Saints parish. For election purposes, charitable distributions and, indeed, for births marriages and deaths, it was important to know in which parish a house stood, particularly if it was near the junction of parish boundaries. The actual marks were placed on the nearest building where a boundary crossed a street or open space. During that period in history when the annual Rogation Tide perambulation of the parish boundary took place, special prayers would be said or some other ceremony carried out at each of the crosses marking the parish boundary.

Parish boundary mark. This particular mark is to be found at the entrance to the Theatre Cellar Bar in St George's Square.

Parish boundary mark. This mark is on the front wall of the Lord Burghley (formally the Rising Sun) in Broad Street. When this pub was refurbished in 1982, the front wall was taken down completely and rebuilt. Fortunately, the builders left the boundary mark intact.

Over the years, as buildings have been altered, many of these marks have disappeared, but there are still a good number existing. Fortunately, when the front of the Lord Burghley pub (Broad Street) was rebuilt, the builders took care to preserve the parish boundary mark, which can still be seen on the east end of the building. Another very clear example can be found at the entrance to the Cellar Bar in St George's Square. Some year ago, a total of twenty-nine parish boundary marks were identified, although some may well have since disappeared when buildings were altered.

Y

York

Visitors to the Castle Museum in York might be surprised to find a building from Stamford in Kirkgate. The building was once No. 60 High Street, and for many years it was a butcher's business; nineteenth-century photographs show that it was last owned by Grants. The shop is a timber-framed building probably of the sixteenth century. The building was dismantled and removed to the York Museum.

Grant's butcher's shop, now in Kirkgate in York's Castle Museum.

York (Duke of)

Stamford had been held by the dukes of York since the fourteenth century and became involved in the struggles that later became known (the term was first coined in the eighteenth century) as the Wars of the Roses. The weakness of Henry VI as a king led to unrest among the country's leading families. Leadership of the country was contested between Richard, Duke of York, supported by the earls of Salisbury and Warwick, and John Beaufort, Duke of Somerset, supported by Queen Margaret. In 1452, York had stirred up unrest in the West Country and in the East Midlands and Stamford became the centre of a rising which also involved men from neighbouring Yorkist estates at Grantham and Fotheringhay. York was defeated and killed at the battle of Wakefield in December 1460. Following the battle, Queen Margaret's army marched south to meet the Earl of Warwick at St Albans. Along the way, many towns of Yorkist sympathy were sacked. In Stamford some of the town's records were burned and it is almost certain that some damage would have been done to property. However, the extent of the damage done by the Lancastrian army may have been overstated by some earlier historians. The survival of glass in St John's and St George's Church windows and Yorkist symbols in St Mary's Church windows suggest that the damage done by the Lancastrians has been significantly overstated. Interestingly, other towns through which the army passed, such as Grantham and Huntingdon, were similarly 'sacked' but do not put any significance on the event in the way that Stamford has.

Z

Zeppelins

Stamford was fortunate that it did not suffer serious damage during either of the world wars. However, during what became known locally as the Zeppelin period (January 1916–October 1917) the area was visited on a number of occasions by these leviathans of the air. On 28 January 1916 a bomb was dropped in the vicinity of Blackstone's works without doing any damage. It appears that this single airship was then joined by two others, and they remained in the area for around three hours, but no further bombs were dropped.

Acknowledgements

The author wishes to thank Stamford Town Council for permission to reproduce the borough coat of arms and the painting of the bull running. Also thanks to David Baxter for permission to use the aerial photograph of Stamford Hospital. Thanks are also due to Daniel Lezano for help with the photography.

About the Author

Christopher Davies lived in Stamford for over forty years, and for much of that time was involved in local history research. For some years he was chair of the Stamford Survey Group. His particular interests lie in the seventeenth century, and he is currently working on a transcription of the Stamford Borough Hall Book for the period 1625–60. His previous publications include *Stamford and the Civil War, Stamford Past, Stamford Through Time,* and *Stamford in 50 Buildings.* He has recently completed a two-year research project on eighteenth-century churchwardens' accounts.